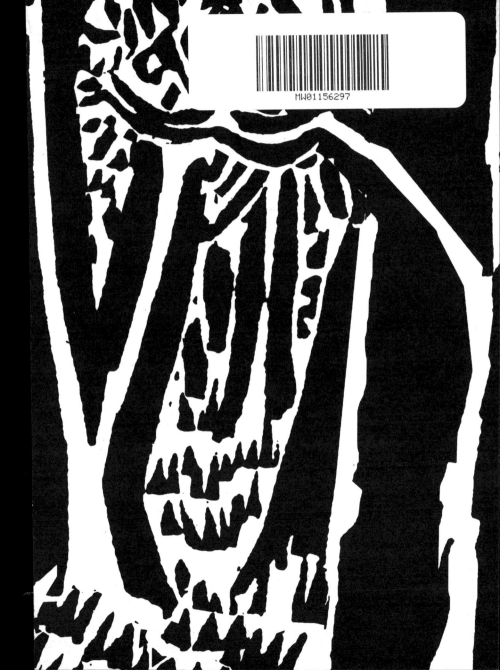

MW01156297

PASSIONATE JOURNEY

A Novel in 165 Woodcuts

by Frans Masereel

Introduction by Thomas Mann

City Lights Books

San Francisco

First City Lights Books edition 1988
New edition, 1994
ISBN: 0-87286-174-0
Cover design by Rex Ray
Book design by Rex Ray and Amy Scholder
Printed in Hong Kong

City Lights Books are available to bookstores through our primary distributor:
Subterranean Company. P.O. Box 160, 265 South 5th Street, Monroe, OR
97456. 5503-847-5274. Toll-free orders 800-2274-7826. FAX 503-847-6018. Our
books are also available through library jobbers and regional distributors. For
personal orders and catalogs, please write to City Lights Books, 261 Columbus
Avenue, San Francisco, CA 94133.

CITY LIGHTS BOOKS are edited by Lawrence Ferlinghetti and Nancy J. Peters
and published at the City Lights Bookstore, 261 Columbus Avenue, San
Francisco, CA 94133.

INTRODUCTION

I should like first of all to say a few words about the two quotations which Masereel has chosen as epigraphs for his *Passionate Journey*.* Not everyone who picks up this book of pictures may be "cultured" enough to read these passages in the original. For you do not have to be as multilingual as a Riviera hotel-waiter or a nineteenth-century boarding-school miss to enjoy and appreciate the work of this great artist—especially in the volume before us. You may, for example, be a worker, a taxi-driver, or a young telephone operator without any gift for languages, and yet be intellectually curious enough, close enough to the spirit of democracy, to know Frans Masereel, to have read him and wondered about him; whereas your Mr. Employer is not "cultured" enough to understand him and does not even want to, because unfortunately he considers Masereel

*The original title in German was *Mein Stundenbuch*; in French, *Mon Livre d'Heures.*

●

"subversive," synonymous with Bolshevism.

This Flemish-European art is so genuinely human, it relies so little on a culture which is not purely inward or a product of ordinary democratic education in our time, that a knowledge of foreign languages is no prerequisite to understanding the epigraphs in this book. We are dealing here with a creative work of such simplicity that you do not even have to know how to read or write to see it: it is a novel in pictures, a kind of movie which, except for two introductory quotations, needs no other words, captions or sub-titles to explain it. It appeals directly to the eye. Nevertheless, it is decidedly helpful if you do understand the rather simple statements which the artist has quoted in order to make clear his own intentions: they immediately give you the "feel" of the pictures.

The excerpt from the American, Walt Whitman, runs: "Behold! I do not give lectures, or a little charity: When I give, I give myself." And the words of the Frenchman, Romain Rolland, read: " . . . pleasures and pain, pranks and jests, experiences and follies, straw and hay, figs and grapes, green fruit and ripe fruit, roses and skyscrapers, things I have seen, read, known, had, and lived!"

I said above that these are simple statements. In them an artist explains, in words of foreign languages he loves, that he has no intention of teaching or exhorting; he wishes to depict not just a carefully chosen part of himself but all of himself. He means to show himself as he is. His life is a dedicated life, the life of an individual—in a sense, man's life. And this marvellous adventure is rich in faces and experiences, invaluable in its mingling of pleasure and pain, happiness and sorrow, joy and bitterness—a life into which we are driven, we know

not why, and from which we will one day be taken, again probably without knowing why. Here is no moralist, no pedagogue, no guardian of souls, no zealot with a one-track mind Here we are in the presence of a good companion—a kind, sincere, naive fellow who lives life to the full and, if he criticizes it for its distortions, does so not out of bitter disillusionment but with natural, unaffected feeling . . . Does that not inspire unusual confidence as a beginning?

It is only a beginning. Here confidence is in order as it rarely is in this time of confusion, in which prophets shout each other down and hucksters cry their wares on both right and left. Confidence—what a virtue that is today! What an opportunity! What an unusual possibility! In the presence of a work of art that offers it, one should give precedence to this deeply reassuring word, this rare quality, this fortunate avenue to emotion—in short, to the human-moral side of art.

I feel this as I write my introduction. I find it terribly difficult and even ridiculous to play the connoisseur and pontifically direct the attention of my readers to linear charms and God knows what other aesthetic "values": it is a question of genuine values, human worth, trustworthiness. And a good book should be introduced by telling why it is good, why the human being from whom it springs deserves our confidence.

In this connection, I have generally observed the following: people find it hard to have faith in a way of life that is only old or only young and new, only traditional or only modern, only aristocratic or exclusively the opposite. The one, sincerely but stubbornly turned toward the past, despises the present as vulgar;

the other, quite free and untrammelled, basically arrogant, without roots or traditions, is solely concerned with the present and future. Both factors must be present if there is to be confidence—nobility and freedom, history and actuality. And it is just this fusion that is most happily expressed in the art of Frans Masereel.

He is a wood-engraver. He practices that old, noble, pious German handicraft, handed down from the Middle Ages through Lucas van Leyden and Albrecht Dürer, through the Nuremberg Chronicler and the Latin *Biblia Pauperum* (Bible of the Poor). It is a conservative art, primitive in material, old-fashioned in technique. Today as five hundred years ago, it requires nothing but a piece of peartree-wood, a small knife—and man's genius. Could such a worthy calling and occupation—in our period of raucous street-noises and shrieking factory-whistles—fail to influence the moods and attitudes of a man who is fundamentally modern and democratic-minded? In his *Passionate Journey*, Masereel depicts himself. Before the giant factories of modern industry, their belching smokestacks, their derricks, blast furnaces, and forges, he scratches the back of his head, leans his chin on his hand and finally, seized by some mysterious panic, takes to his heels with his arms outstretched.

At the very outset, in a title-picture, he shows himself at work. Peering through his glasses and seated at a simple table, he engages in his pious task of creation. Before him are bits of wood and tiny tools for cutting and piercing. Thus he spends hours every day, with the passionate patience of a handicraftsman. He progresses slowly and deliberately, sincerely and creatively, in exactly

the same way as those medieval masters who were his forebears. I have been told that he is no artist of moods, dallying for weeks and then producing his works of genius with a sudden burst of explosive fury. He prefers consistent daily work; to him, diligence is the highest form of passion. He is now only thirty-seven years old* but has long since produced his first thousand woodcuts, not to speak of the thousands of his drawings. What concentration!—the concentration of genius, without which such a passion for work is inconceivable. And what self-possession! It is of course wrong to say that genius is diligence, that diligence creates genius. But the idea that the two are somehow bound up with each other is quite valid—the order, however, should be reversed. Genius creates diligence, demands and compels it. At least this is so in the case of masterworks—and here we are in the living presence of mastery over form. The form itself is traditional, conservative, age-old; it is romantic and turned toward the past. Hence it would not arouse complete confidence were the content not imbued with such immediacy and such sustained modernity that the old and the new, the traditional and the dynamic fuse to inspire human confidence.

Seldom has raciness so blended with conviction as here in the contrast between a fundamentally old and traditional technique and the sharpness and contemporary boldness of the things it expresses. Masereel has produced a volume of woodcuts called *The City*—in its hundred illustrations he has mirrored our entire civilization as seen by his penetrating and pitying eye. He has depicted the brutal fantasy of modern life, grotesque and horrible in its inexorable vulgarity. It is crowded with contradictions, contradictions of the diabolical and the

• In 1926.

damned. As you thumb through this German-Flemish "block-book" brought up-to-date, you pass in review all the coarsest aspects of the present. It is a present that has been tried and convicted by a graphic artist who is himself so much a part of the present that in the impact of his art he is closely akin to one of the most characteristic products of our times. For is not the play of black-and-white on a movie screen a democratic pleasure? Has it not succeeded in charming even the most exacting intellectual aristocrat?

I have already alluded to the movies, as does everyone who discusses this artist. Darken the room! Sit down with this book next to your reading-lamp and concentrate on its pictures as you turn page after page. Don't deliberate too long! It is no tragedy if you fail to grasp every picture at once, just as it does not matter if you miss one or two shots in a movie. Look at these powerful black-and-white figures, their features etched in light and shadow. You will be captivated from beginning to end: from the first picture showing the train plunging through dense smoke and bearing the hero toward life, to the very last picture showing the skeleton-faced figure wandering among the stars. And where are you? Has not this passionate journey had an incomparably deeper and purer impact on you than you have ever felt before?

Recently, a film magazine published abroad asked me if I thought that something artistically creative could come out of the cinema. I answered: "Indeed I do!" Then I was asked which movie, of all I had seen, had stirred me most. I replied: Masereel's *Passionate Journey.* That may seem an evasive answer, since it is not a case of art conquering the cinema but of cinema influencing art.

At any rate, it involves a meeting and fusing of two arts—the infusion of the aristocratic spirit of art into the democratic spirit of the cinema. What has hitherto been purely a pleasure of the senses is here intellectualized and spiritualized. And if movies are usually nothing but pure sensation, without art, here we have an artistically produced film of life, a human life lived in art and the spirit, a dedicated life, if you will. The pious "block-book" of olden days has here developed into a stimulating and entertaining movie. As a matter of fact, Masereel is very fond of the cinema and has even written a scenario himself. He calls his books "*Romans en images*"—novels in pictures. Is that not an accurate description of motion pictures? The wood-block in which this Fleming silhouettes his plastically drawn figures against broad surfaces of light is akin to the small white screen of the cinema. We expect so little of that narrow screen as we sit down in front of it; yet when pictures flicker on it before our eyes, we marvel at the way in which life seems to open out.

These picture-novels, mute but eloquent creations, bear such titles as *A Man's Path of Sorrow, The Sun, The Idea, The City*, and they are all so strangely compelling, so deeply felt, so rich in ideas that one never tires of looking at them. But the most personal, the most intimate, the warmest, the most human, and the most candid of them all is this *Passionate Journey.* It is such a popular work that it is quite natural and fitting for a publisher to want to take it out of the realm of the esoteric and make it available to the worker, the taxi-driver, and the young telephone-operator. It belongs much more to the common people than to the snobs; and I am happy to do my part in making it better known to the demo-

cratic-minded public.

Frans Masereel was born in 1889 in Blankenberghe (Belgium), the son of well-to-do parents, and grew up in Ghent. The young etcher, woodcutter, and illustrator was twenty-five when World War I came. He had illustrated many books: volumes of Emile Verhaeren, Pierre Jean Jouve, Romain Rolland, Georges Duhamel, and especially Charles-Louise Philippe, before he found his own specific direction. The war marked a turning-point in everyone's life. It changed Masereel from a Flemish realist into a European artist. He has said so himself. Speaking to his compatriot, Henri van de Velde, he declared: "Before the war, I delighted in crude, genuinely Flemish realism: carnivals, open-air dances, whores and sailors . . . I have whole piles of sketches of life—on the street, in courtyards, in shabby taverns. I have always worked hard . . . But the deepest meaning of all these things eluded me, and I feel that the war did much to make me understand them." In sum, he had been national-minded and a realist; the war europeanized and spiritualized him. That is a typical and familiar process: the search for ideals under the impact of war, the spiritual drive, the revaluation of all values, which war imposes. But rarely has that experience brought about such an artistic heightening and intensification, such an increase in human and world insight as in the case of Masereel. He had been a run-of-the-mill sensuous talent, making sketches in Belgian alehouses. War made of him a spiritual figure, a voice of the people's conscience.

Is he then a revolutionary? I trust that the slight hesitation with which I answer that question in the affirmative is not misunderstood, for of course it has to be

answered affirmatively. I said above that Masereel's art accuses and condemns our civilization; I also said that if it criticizes the distortions of life and society, it does so on the basis of the freest and most natural human emotions. In other words, it criticizes artistically and not because of disillusionment over shattered ideals. I feel that he lacks something in order to be a pure and true revolutionary. The prophet of political salvation is necessarily a man of a single idea, a man of doctrine and power who knows exactly what he wants and strives to accomplish it without counting the cost. I do not think that Masereel possesses that knack or even that he feels it his business to acquire it. To be sure, he tells in symbolic pictures the tragi-comic story of an idea—but what idea does he invoke if not that of an honest and free humanity? As you leaf through his book, you see that it is inconceivable for such a man, whose very being breathes sympathy for the things of this world, to interpret that idea as fanaticism, dictatorship, or spiritual enslavement. As I express this incredulity, I find myself thinking over and over again of the psychology of confidence to which I have referred earlier. I should like to complete my thought by venturing to assert, on the basis of experience, that today men's confidence is not placed in power-drunk fanatics. Men refuse to pin their faith on those who are prepared to wallow in blood for the sake of the omnipotent state, who are all too ready to make a clean slate of the past and sacrifice two-thirds of humanity so that the last third may be totalitarian. Masereel has taken one of his epigraphs from Romain Rolland—nor is this accidental, for his case is similar. Rolland's authority and renown, heightened during the disgraceful spectacle of World War I, sprang

from his fundamentally human attitude and his sense of conscience. Rolland loved ideas more than The Idea. He was a man of good will—and his good will liberated rather than enslaved.

You may even find in Masereel the creative artist that worldliness, pure delight in the adventure of life, takes the form of a certain playfulness, a certain irresponsibility, so that his revolutionary side remains just an episode. It is included among the many other adventures he has genuinely lived through, among his other "experiences and follies," without receiving any undue emphasis. In his *Passionate Journey* there are eight pictures portraying the hero simply as a friend and lover of children, as a "big brother" to the young, standing on his head for them, telling them stories, playing games with them. More than a dozen woodcuts deal with women, the raptures of the body, disappointments in love. No less than ten express the majesty of the sea. Thirteen tell of distant journeys to the land of the Moors and of the Chinese. Then there are those in which he does everyday, inconsequential things: boxing, dancing, playing an accordion, folk-dancing at a picnic, climbing and shooting, eating well, drinking and sleeping, skating and bicycling, strolling and lolling in the fields, occasionally even saving somebody's life . . . All this is really too planless to be considered a virtuous life, the life of a revolutionary. It does not involve principles. So it is not incongruous to see our hero burst with laughter at the sight of a bejewelled priest and then, one day when his anguish and disgust are great, to encounter him in a church, bowing his head and kneeling in the mystic atmosphere of muted sorrow. Experiences and follies . . . Four of the 165 pictures pre-

sent him listening to a speaker at a mass meeting, studying social problems in a library, even making a revolutionary speech himself and stirring a crowd of men to revolt. Then come other adventures, showing that he has also sown his Socialist wild oats.

That, I say, is the outward appearance. On the surface, fun, trial and error, playing the game of life. But there is one picture—look at it, it is the richest of all. Its meaning is clearly conveyed: the catharsis of human suffering. The Eternal has cast him down. Amid legendary flowers he extends his arms and lies as if dead in the foliage, behind which the evening sun sets. Then a storm begins to rage. Stamping and clenching his fists, he tramples on his heart, his sensitive human heart. And now, quite free and nonchalant, his face a skull, one hand in his trouser pocket, the other jauntily upturned, he begins his cosmic journey and trades jokes with the stars . . . do you understand? Going through life, sharing its sorrows, was not such a callous journey. It involved the heart; it took a very heavy toll of the heart. Release, a free and easy life without sorrow or love, only came afterwards. It was his heart, his accursed human heart, that forced him to live, profoundly affecting the course of his life, causing him to love and to suffer, making him laugh and curse at the false, the shoddy, the vulgar, and the unfeeling. His heart, not Socialism, made a revolutionary of him, even when he indulged in pranks and follies. For the true revolution is not "in principle," not in "The Idea"—but in the human heart.

The psychology of confidence is a willful and capricious psychology! If I have analyzed it, I have done so because of its bearing on the problem of artis-

tic creation—a problem that is still crucial, more crucial now perhaps than ever before, whatever may be said about it. For there are those who assert that art is finished, its role played out. They claim that in our period of history nothing more is expected of the artist or his "aesthetic" life, that the artist has nothing more to say. Nowadays, so much is investigated, tracked down, and proclaimed as dogma that the bloodhounds and dogmatists often go right past the truth and hand down judgments which deserve simply to be tossed aside. Thus, for example, this notion of the untimeliness or untrustworthiness of the artist. But how easy it is to prove that today artistic creation alone enjoys and merits human confidence. One can prove it by this book with its woodcuts, with its autobiography in pictures of a man who sits in a train and rushes toward life. He does not really belong to any of its forms. He sees nothing reasonable about it and insists only on living with his heart.

Look at him in one of the very first pictures: he stands on the steps of the train in the midst of travellers rushing to and fro. What is he? How is one to place him? What manner of man is he? What is his occupation? To what social class does he belong? One cannot tell. To no class, apparently. He is not of the middle class; he does not even wear a hat, as all respectable citizens do. In a later picture this hatlessness is amusingly exploited. We see a well-fed burgher lose his hat in a storm. Our hero, with turned-up collar, stands there and roars with laughter at the sight of the panicky Philistine lunging after his careening hat. Nor does he seem to be a worker either, certainly not a class-conscious one. His clothing is nondescript; his attitude is neither arrogant nor vulgar, just

comfortable, natural, relaxed—human. There is something pure, strange, free, unattached in his bearing as he remains here on the train-step alone in the crowd. As you follow him, you get the impression that he is on earth like a visitor to a strange land whose customs and spectacles he appreciates and in whose life he participates with a feeling, all-too-feeling heart. Yet to him, the foreigner, all this merely adds up to "experiences and follies." Eventually too, the hatless man makes a clean break with this world of philistinism in which he finds himself completely out of place. There are a few pictures in which he exhibits his contempt for this philistinism in such a violently Flemish way that he has to flee an irate mob of the "right-minded." The world has had enough of him and he enough of the world. He has even had enough of love, judging from the gesture with which he exits through the door. Then his life-journey comes to an end. A mystical *dénouement* begins. And he tramples on his heart . . .

Gazing at him, you wonder what can he "be"—this tall hatless fellow who almost always keeps his hands in his trouser pockets in a nonchalant fashion that contrasts sharply with the passion with which he goes through life and which endears him to children all over the world? Moorish children as well as white children love him and climb up on his knees when he visits them. Occasionally, you see him working: cooking, washing, tilling the fields. But it is clear that these acts too are merely "experiences and follies," brief parts he plays, tolerated out of naive love of mankind. Surely, however, his humanity must fit into some category of class and occupation. Yet it does not fit into any. It is classless. So he is probably an artist; that is the only supposition possible.

For only the artist is classless, declassed from birth. If he is born a worker, his intellect and *noblesse* bring him close to the middle class. If, as almost all artists today, he is a product of the middle class, again his intellect, freeing him of social ties, alienates him from his class, makes him suspicious of middle-class interests, and carries him much closer in spirit to the worker, even though he is likewise mistrustful of the latter's class interests. His classlessness is not utopian; it is a natural result of fate and genuine at all times. It is this that surrounds him with an aura of purity, strangeness, detachment, something which in former times would have been called "saintliness"; and it is this too which, in a world shattered and torn asunder by implacable class conflicts, makes him, the outsider, the uninvolved, the pure guest, the only one secretly enjoying the confidence of humanity, despite all the suspicion the "practical" man inevitably feels toward the intellectual and imaginative man.

Take his work—this old-new, aristocratic and free, traditional and contemporary product of his diligent hands, the pictorial masterpiece of an artist's life! Mingle with the hero in this marvelous and many-faceted world of human beings; be amazed, laugh, and let yourself be carried away! Share in his ecstasy when for the first time he finds happiness with a woman, the carnal and metaphysical happiness of love. He is so blissful that he drapes his arm around the neck of an old coach-horse. Yes, live with him! He feels the beauty of helping man and beast, the sacred value of the simplest gifts of God: sleeping next to an open window, awakening refreshed in the early morning, swimming in the vast ocean. He will take you with him to distant lands of wonder, to dark-skinned

and yellow-skinned human companions. Then see what happens: see how he plays upon your tenderness and wins you entirely. Let worry and disgust bring bitter intoxication, until the streets reel about you. Follow the exquisite story in eleven pictures, in which our hero takes in a victimized young girl and is happy with her, only to see his beloved waste away and die, and in the despair of his last agonizing sorrow bury his head on her death-bed. Sob with him behind her poor coffin, and turn again—since it must be so—to a new life, new beatings of the heart. As you go through these pages, immerse yourself in the great riddle of this dream of life here on earth. It is as nothing since it ends and dissolves into nothingness. Yet everywhere in this nothingness, quickening it to life, the infinite is at hand! Look and enjoy and let your joy in contemplation be deepened by brotherly confidence.

Thomas Mann

Translated from the German by Joseph M. Bernstein

Behold! I do not give lectures, or a little charity:

When I give, I give myself.

—Walt Whitman

. . . des plaisirs et des peines, des malices, facéties, expéri-

ences et folies, de la paille et du foin, des figues et du raisin,

des fruits verts, des fruits doux, des roses et des gratte-culs,

des choses vues, et lues, et sues, et eues, vécues!

—Romain Rolland

(Colas Breugnon)

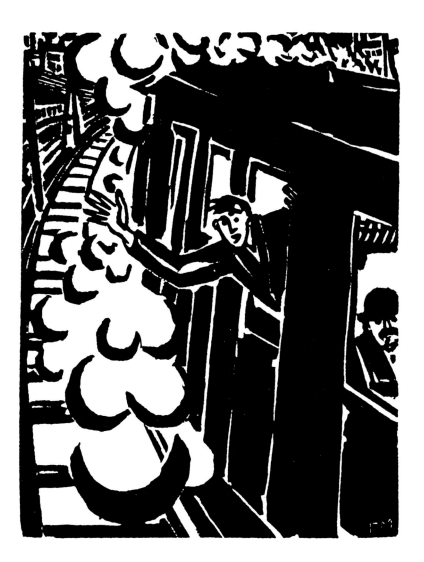

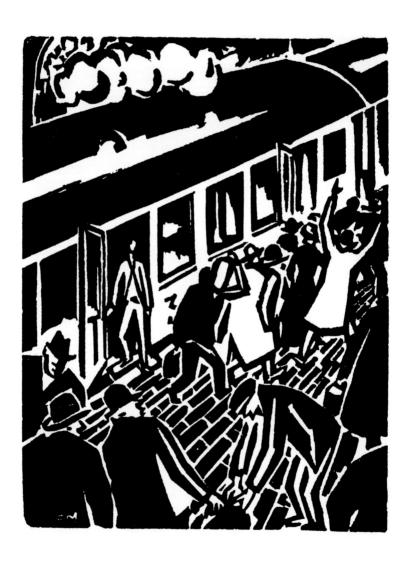

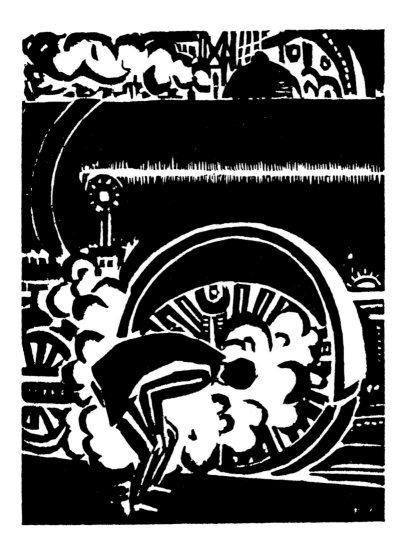

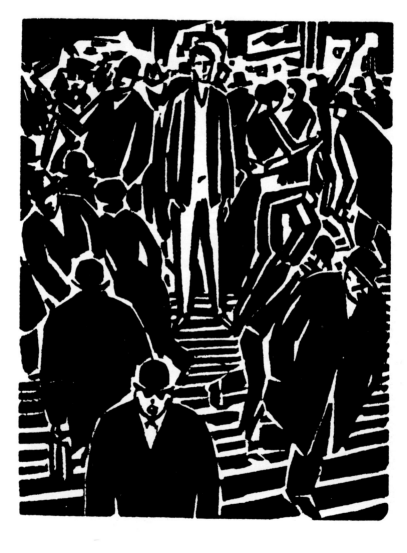

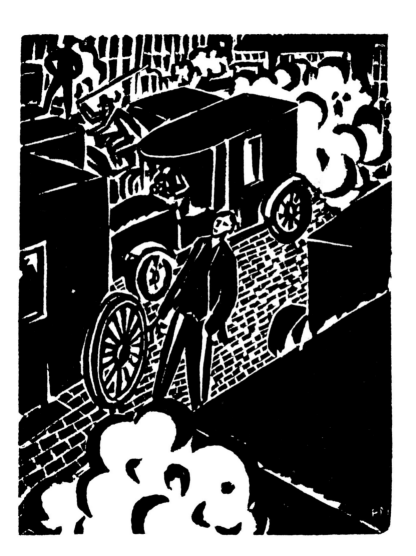

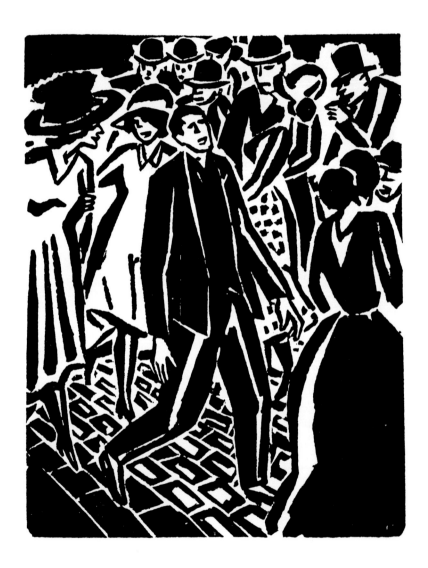

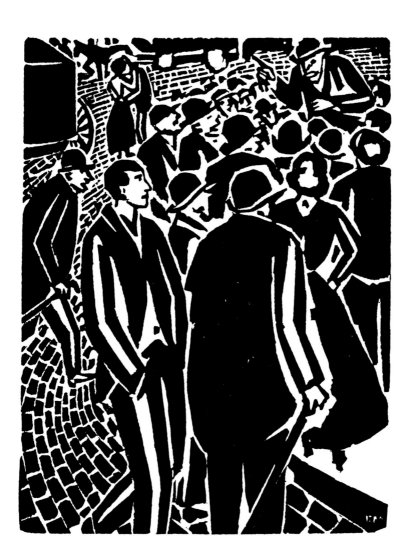

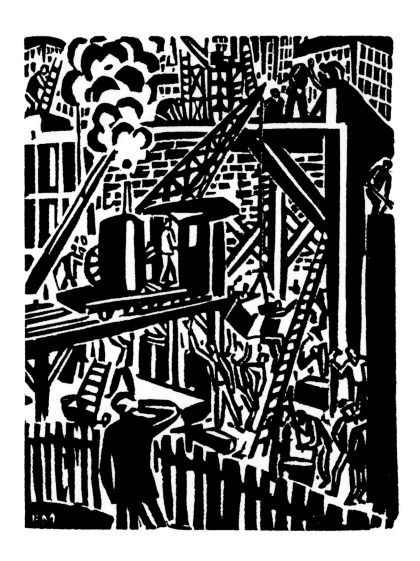

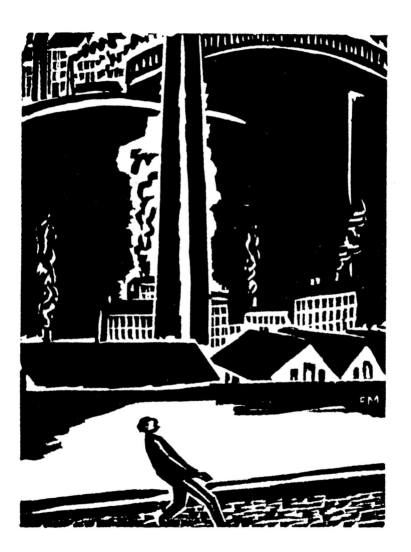

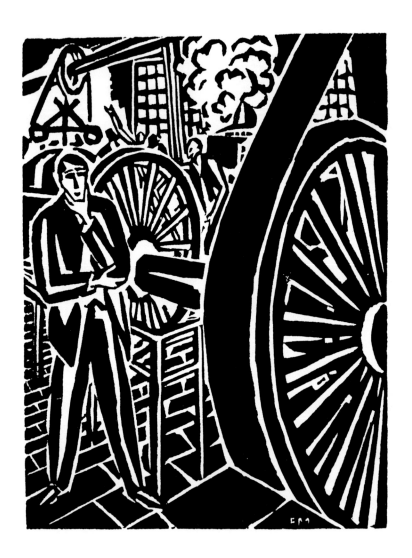

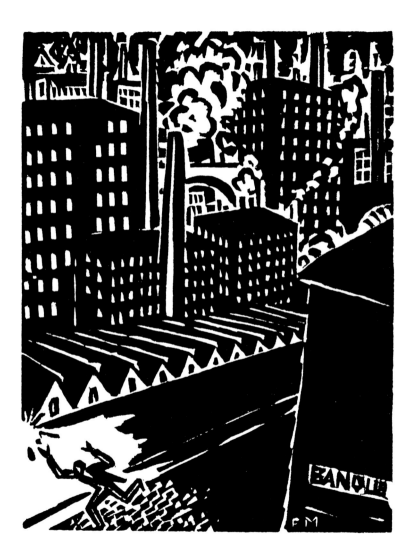

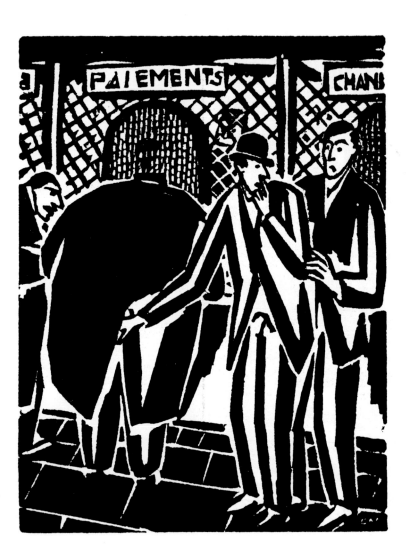

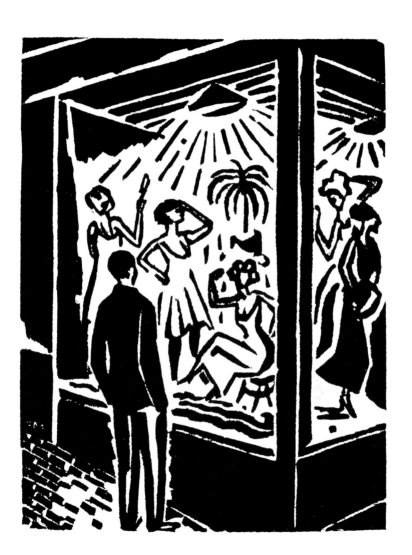

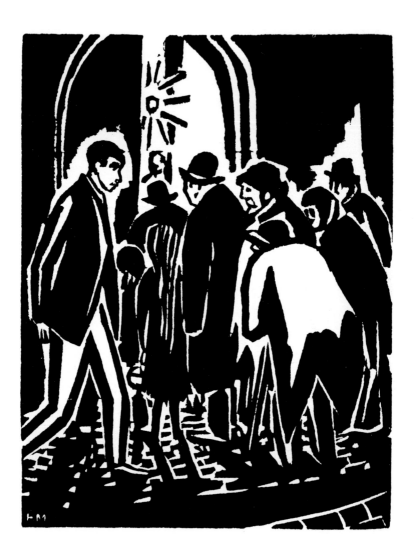

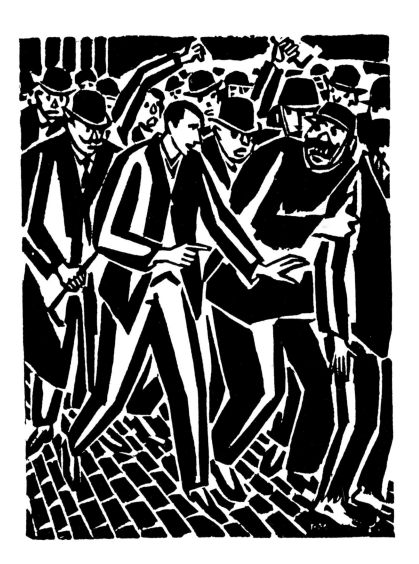

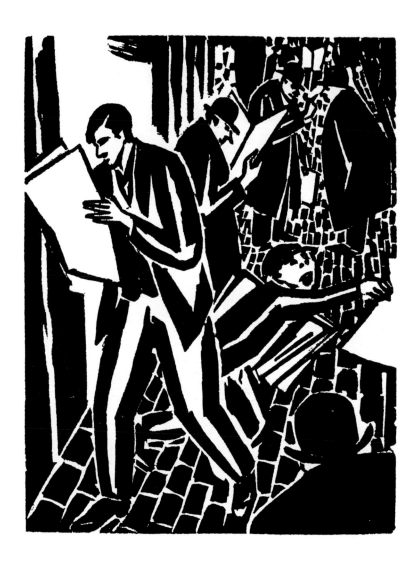

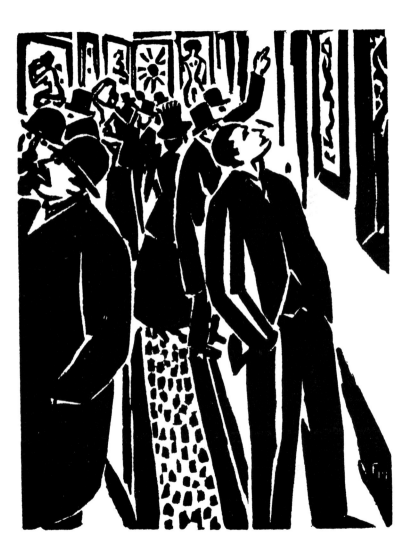

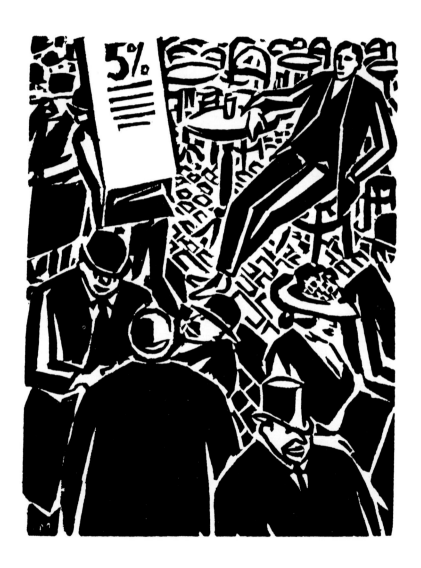

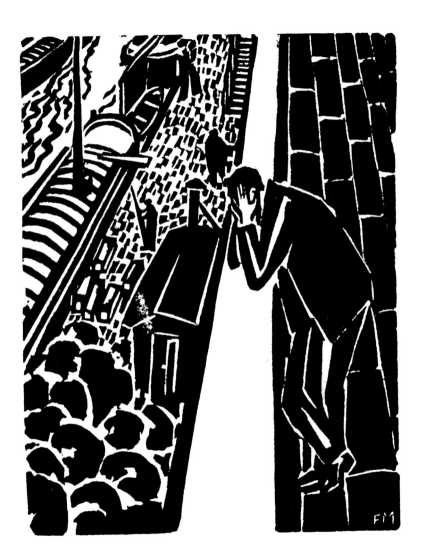

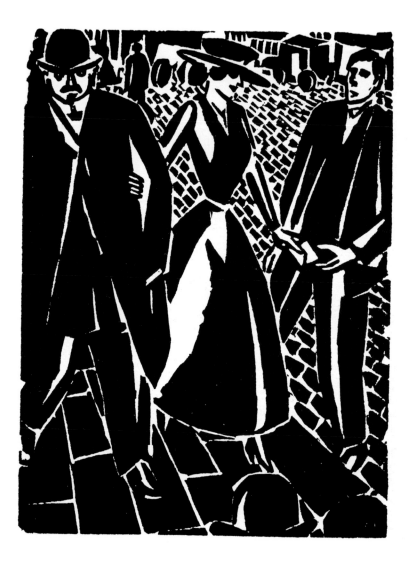

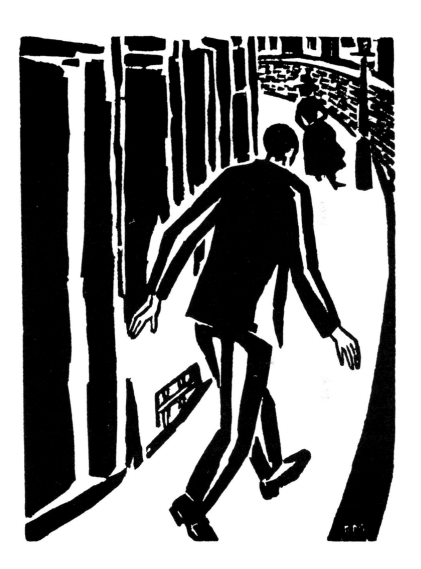

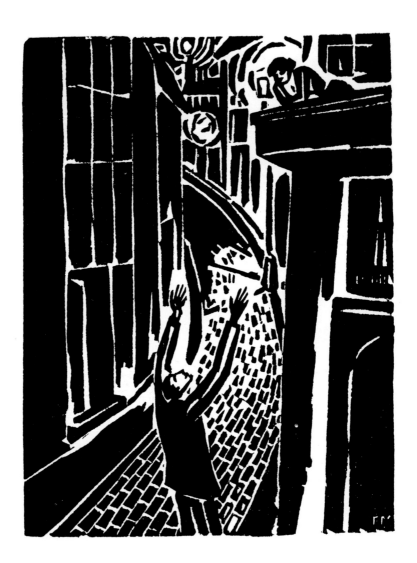

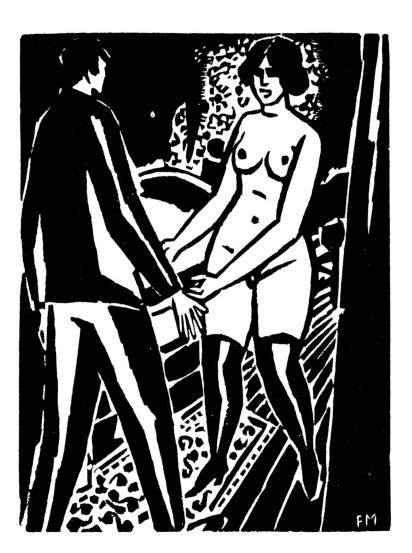

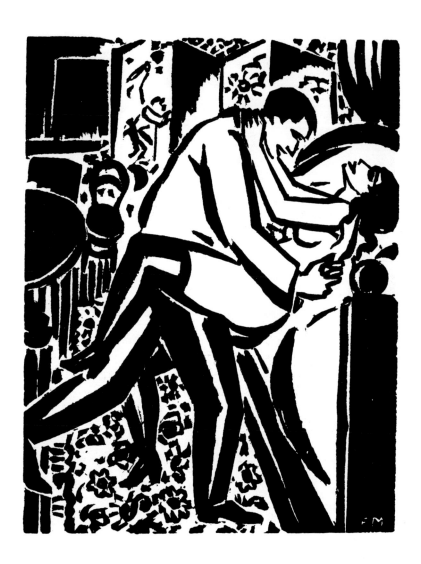

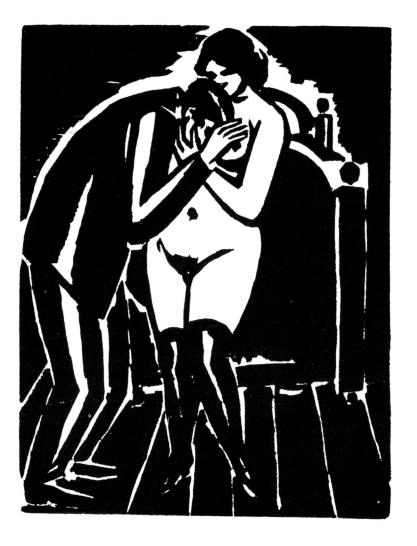

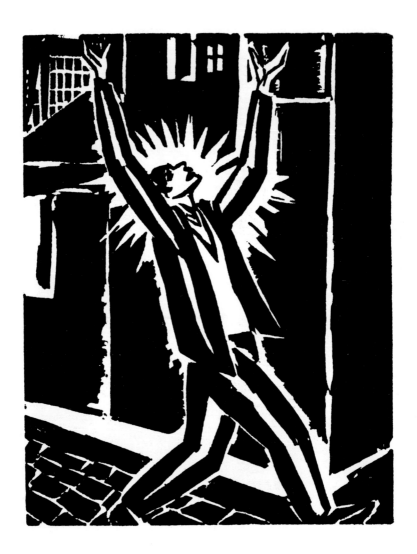

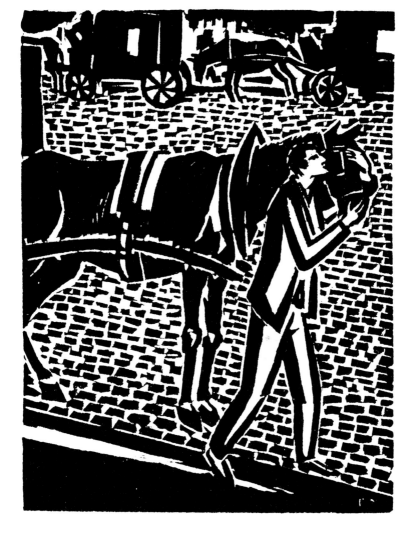

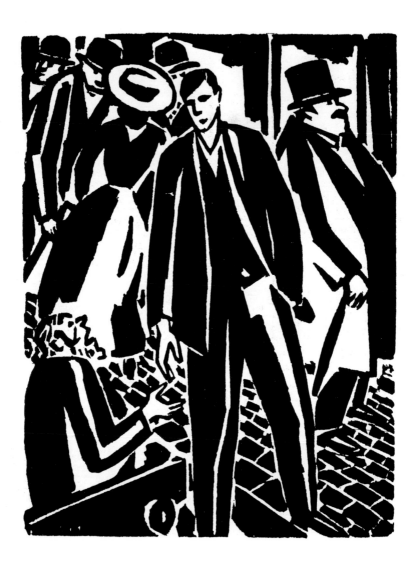

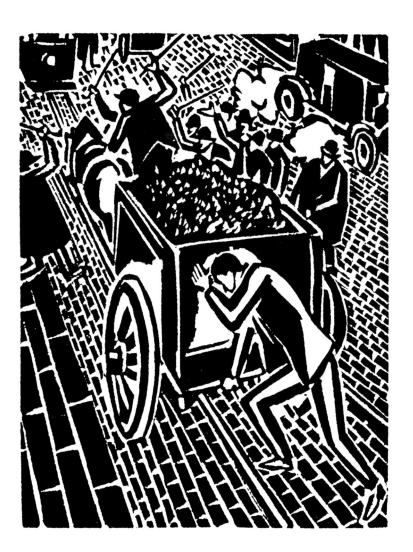

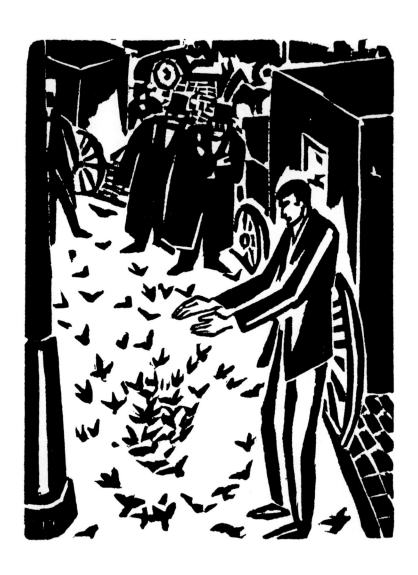

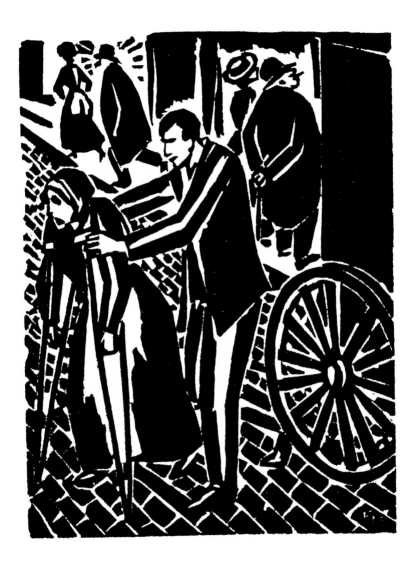

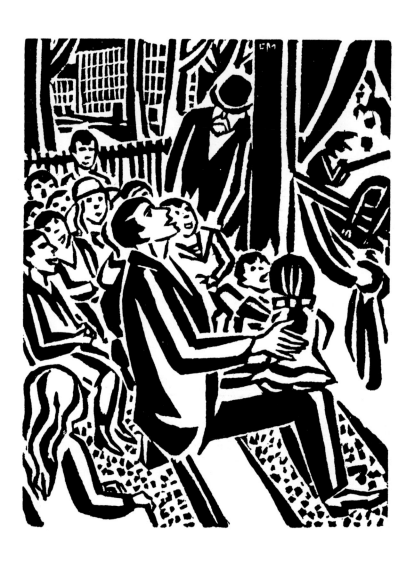

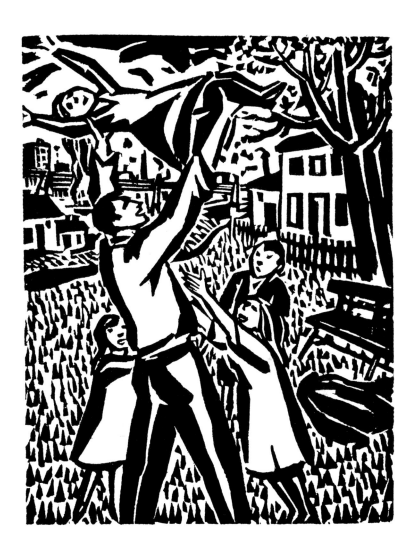

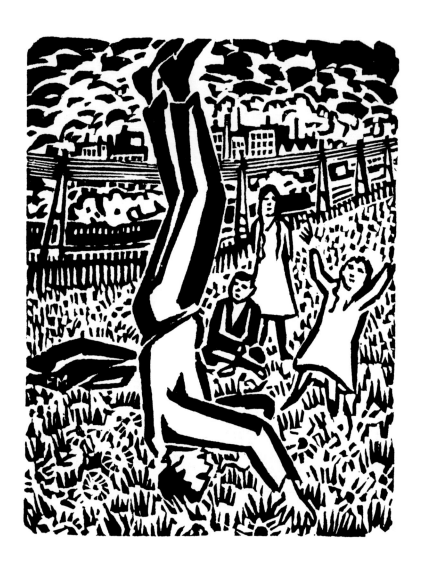

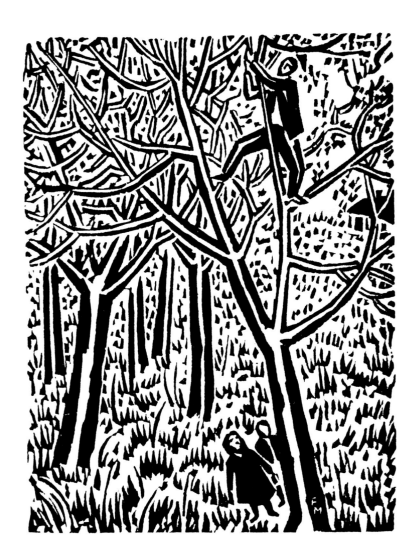

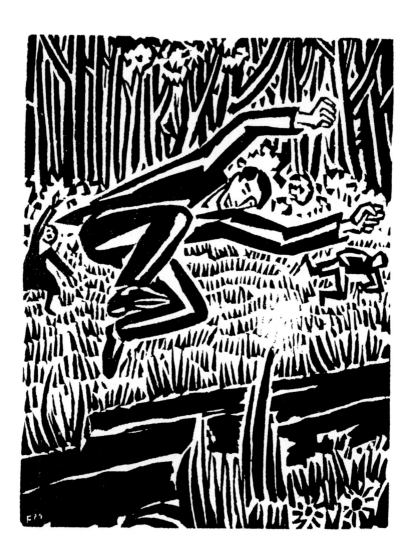

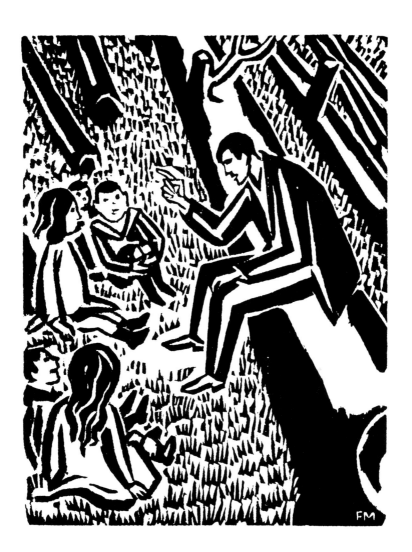

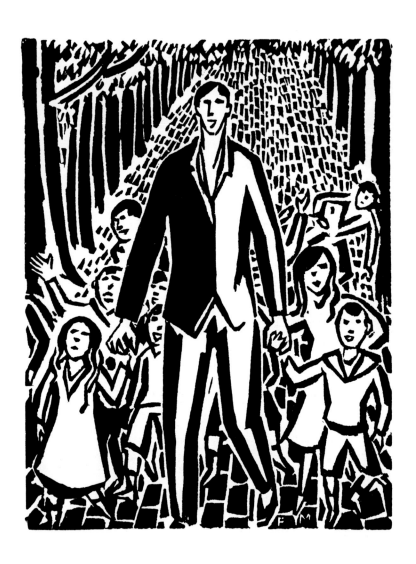

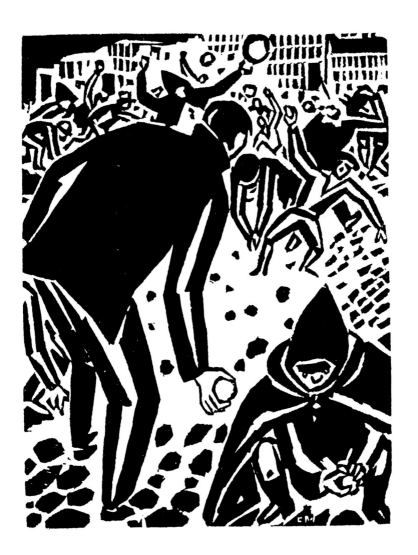

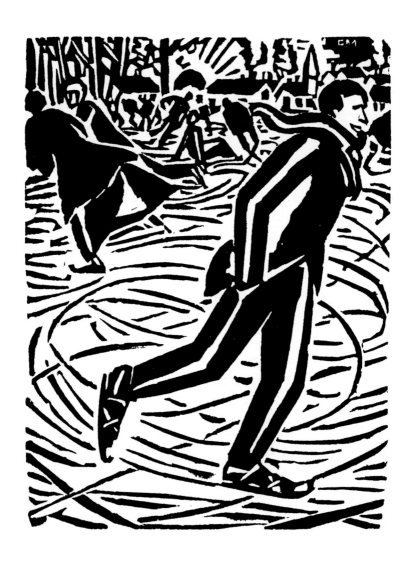

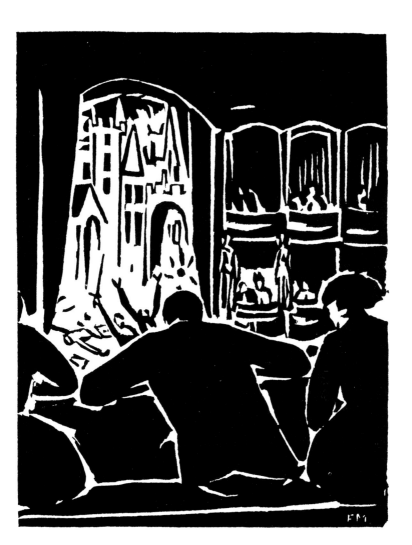

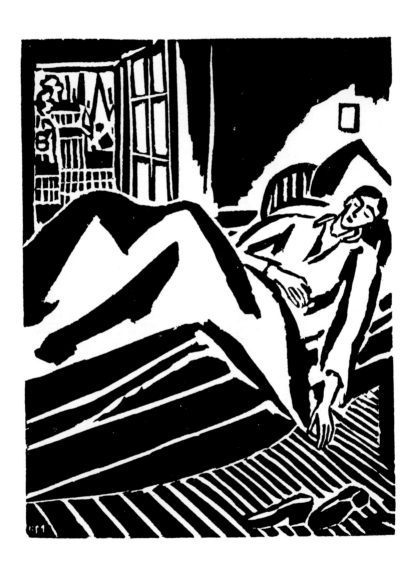

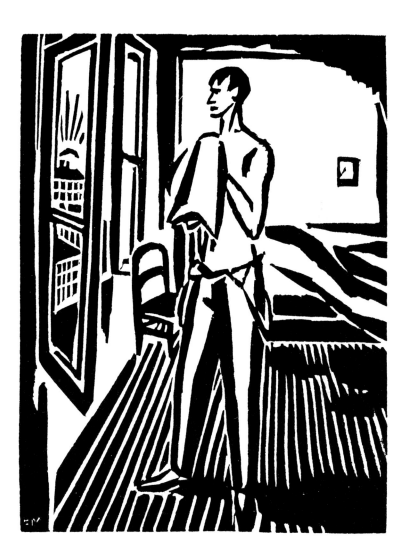

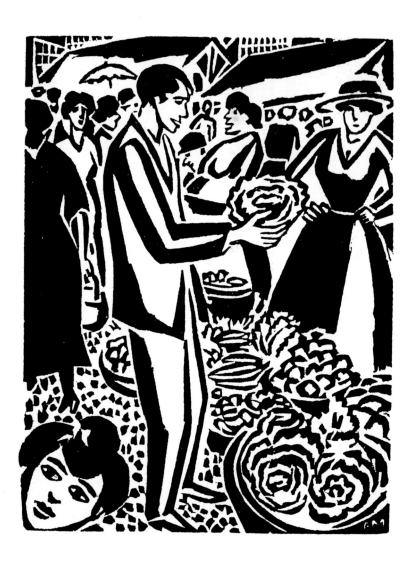

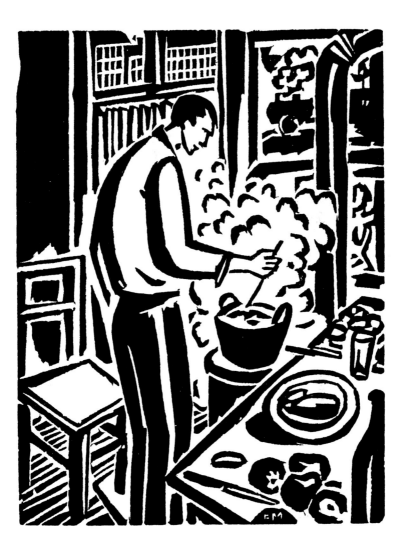

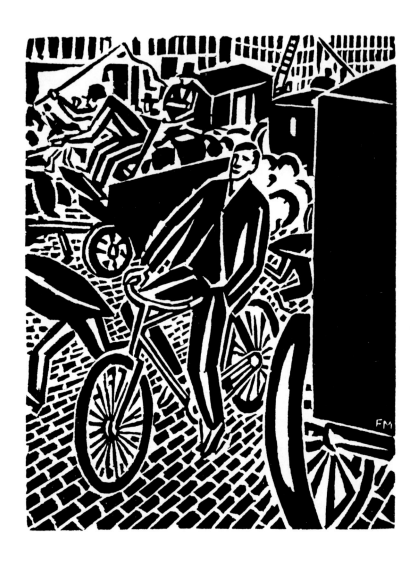

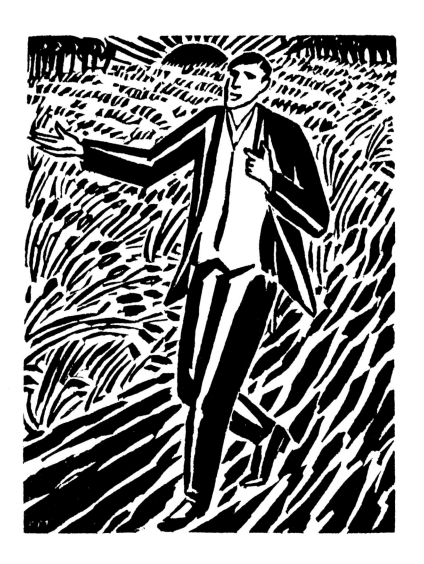

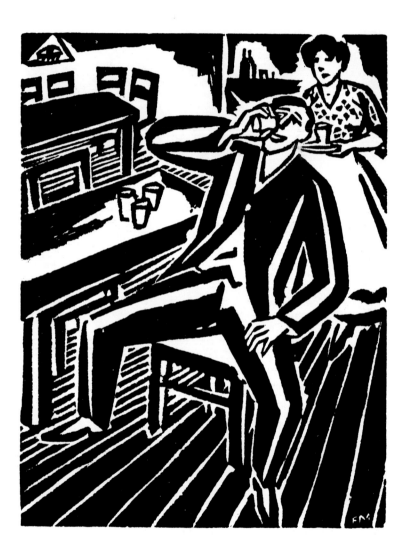

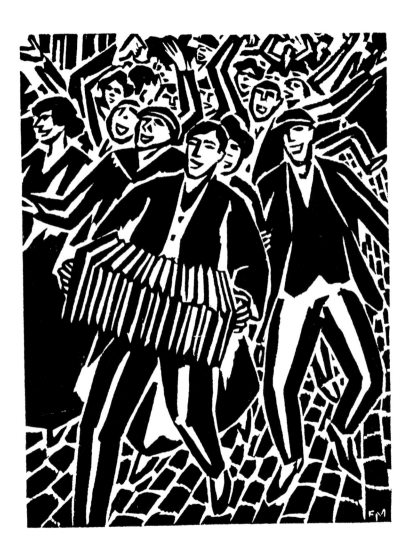

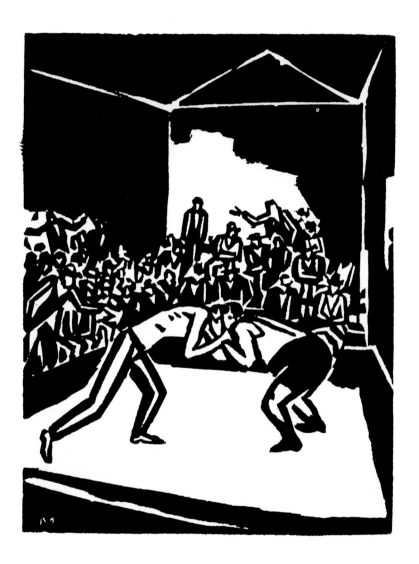

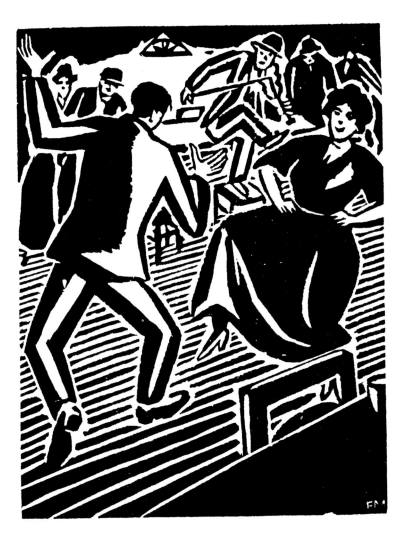

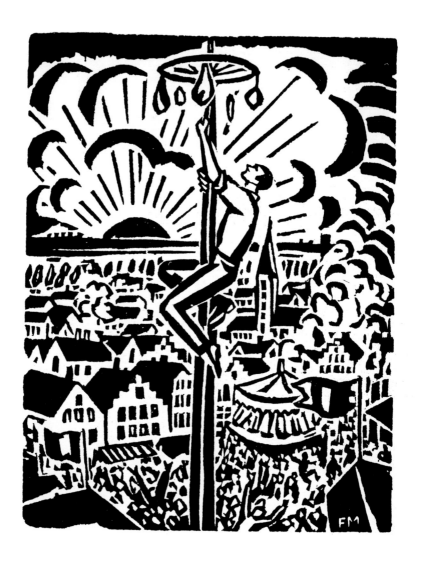

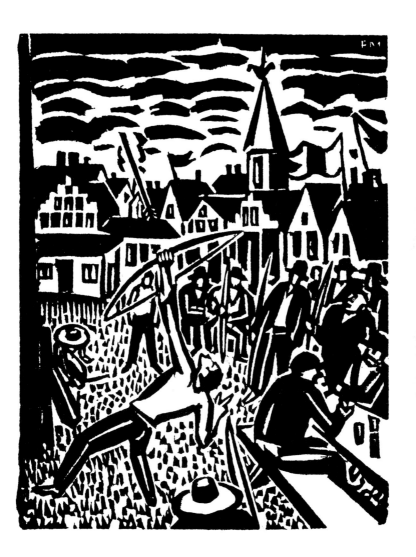

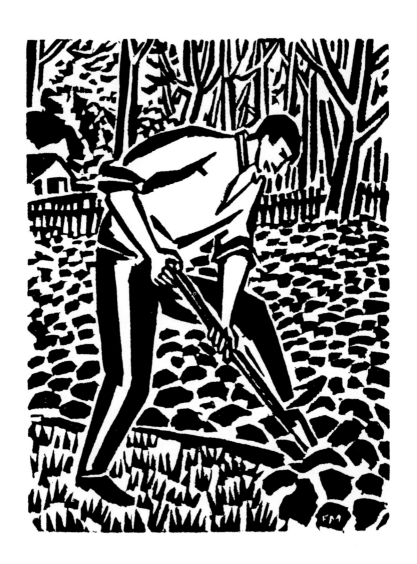

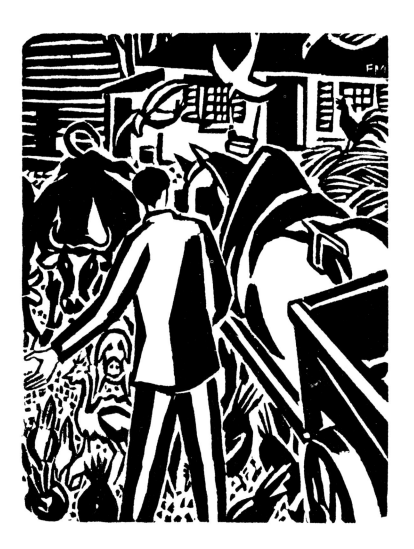

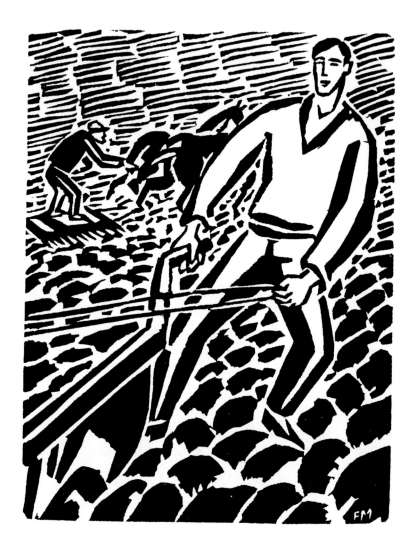

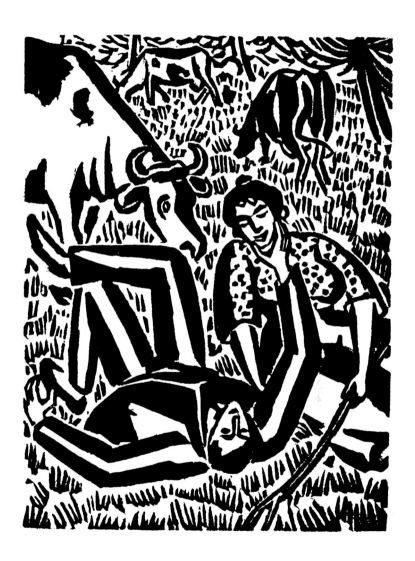

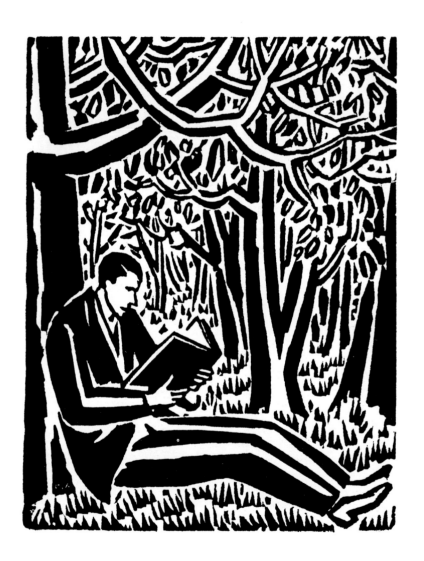

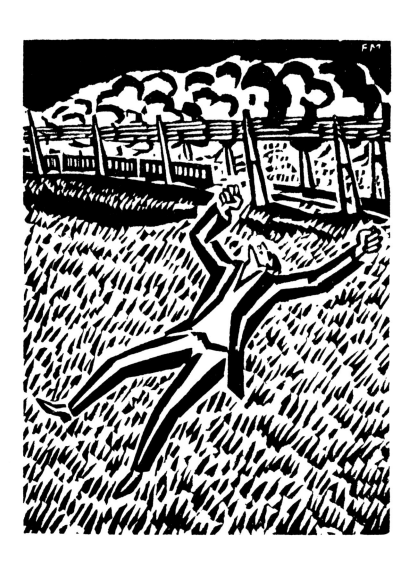

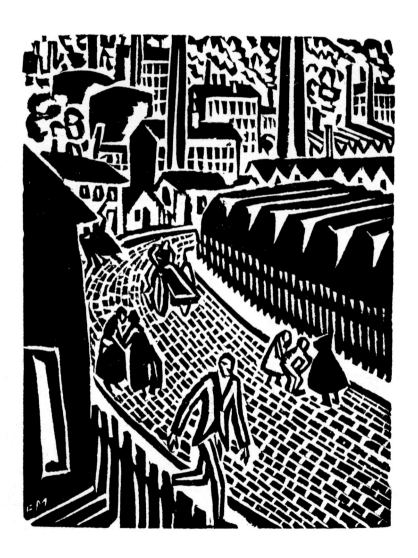

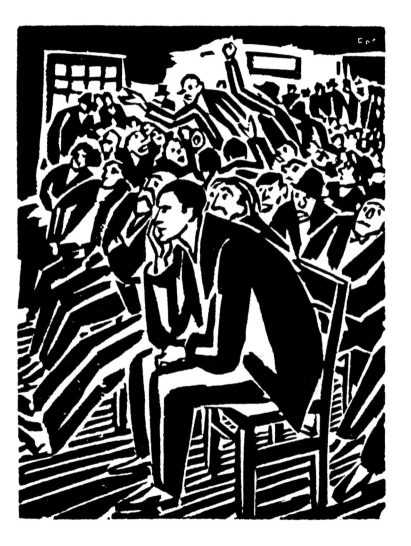

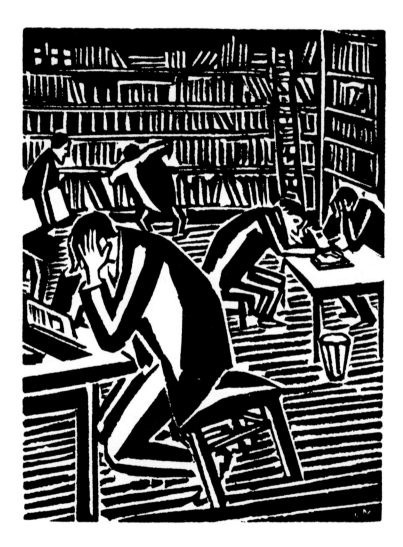

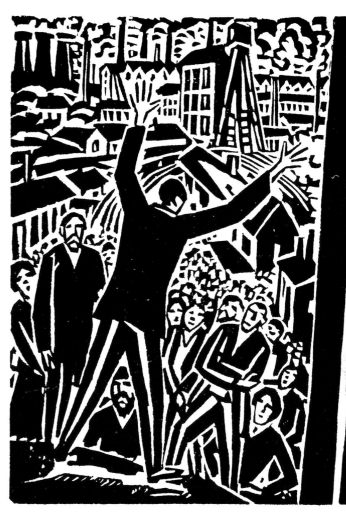

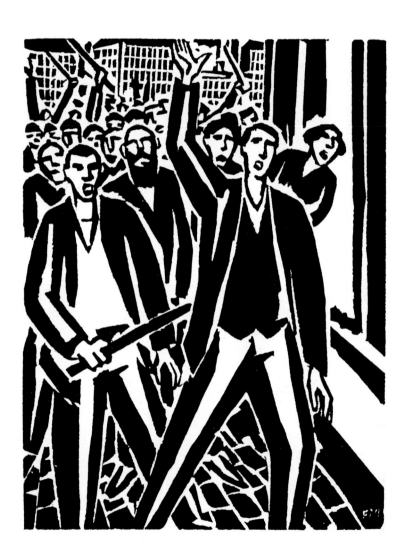

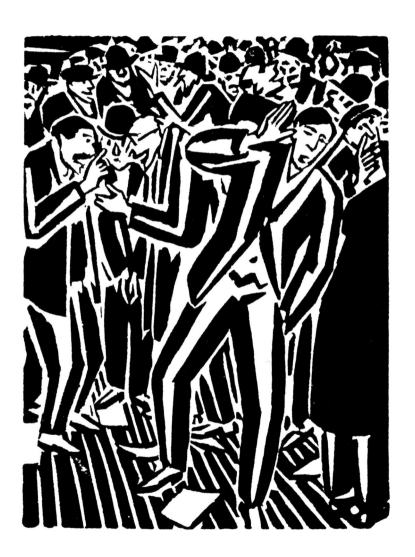

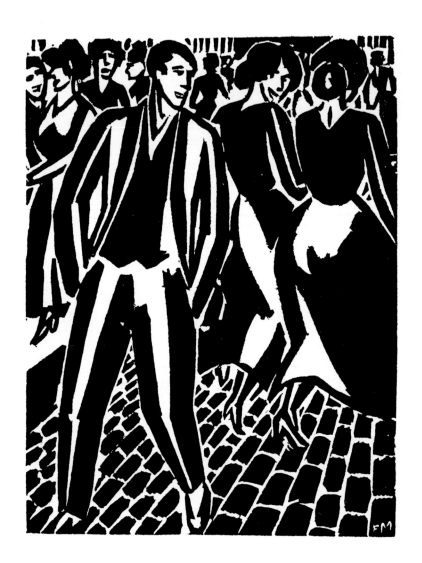

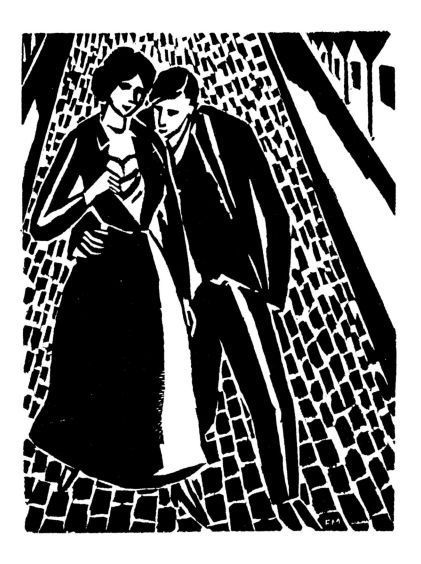

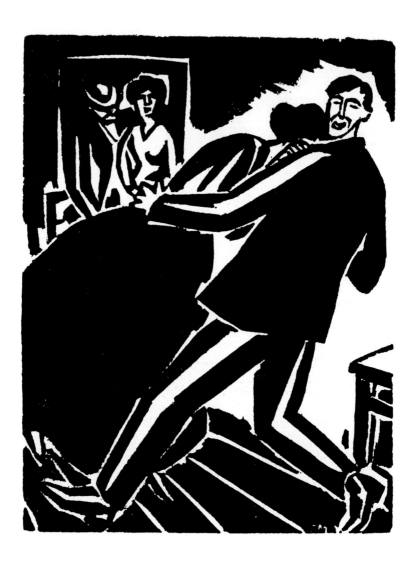

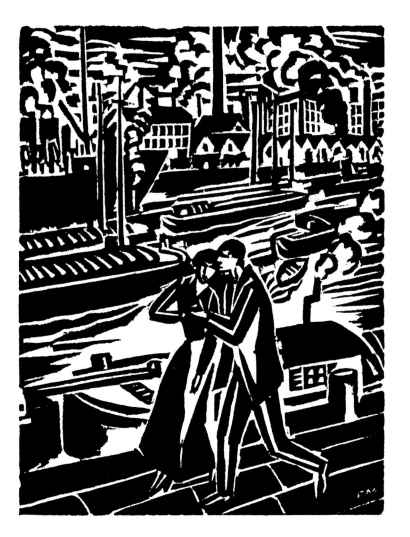

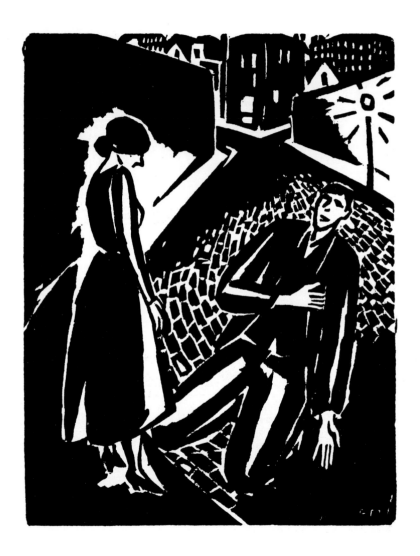

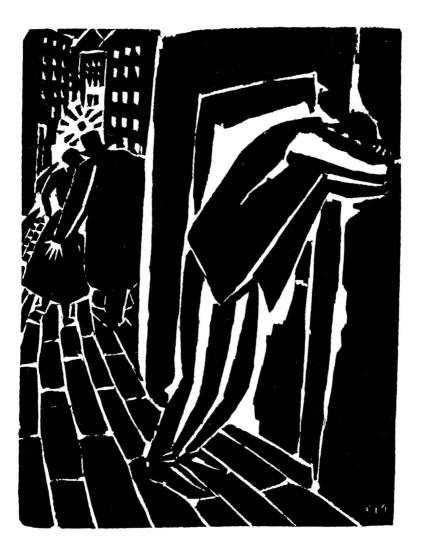

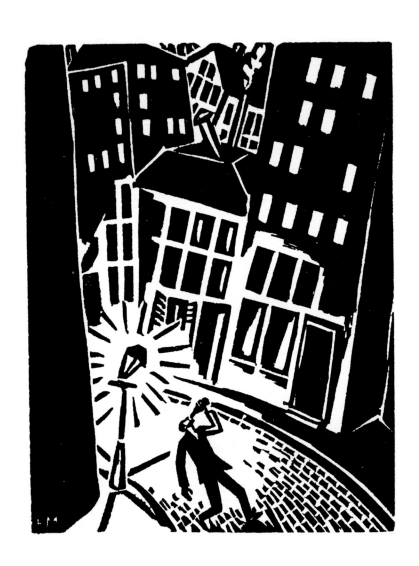

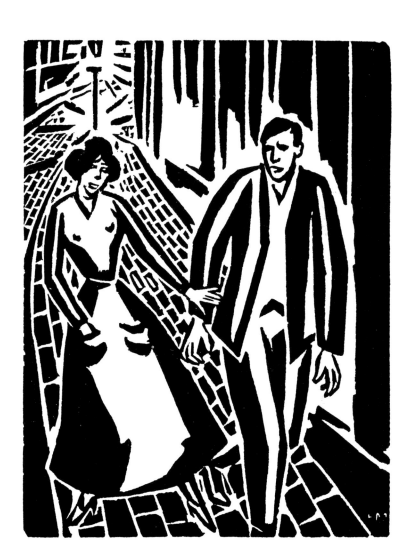

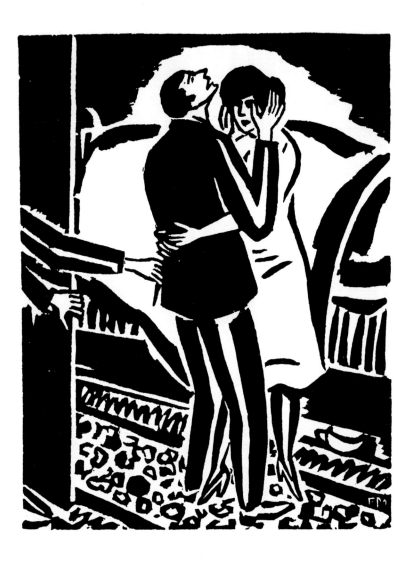

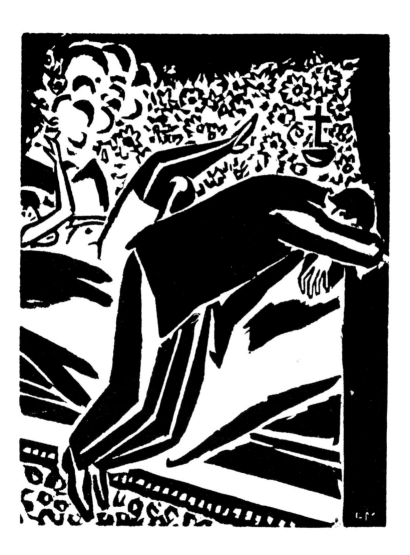

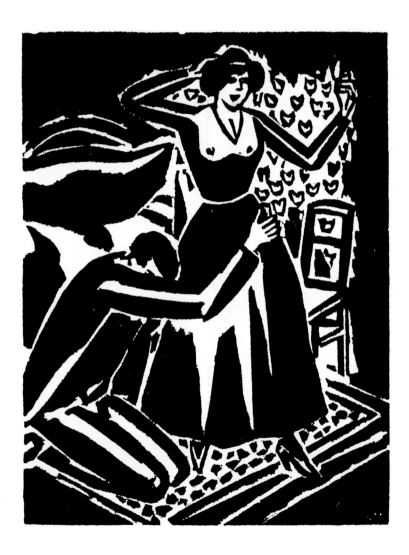

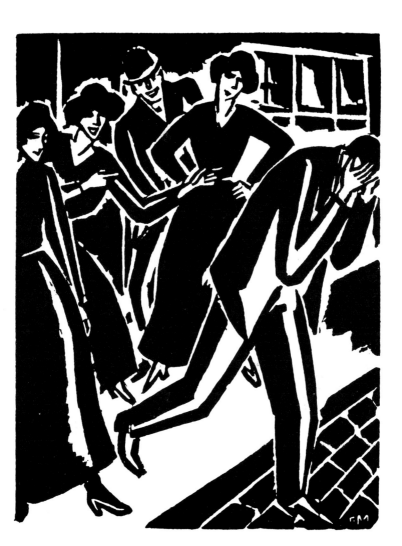

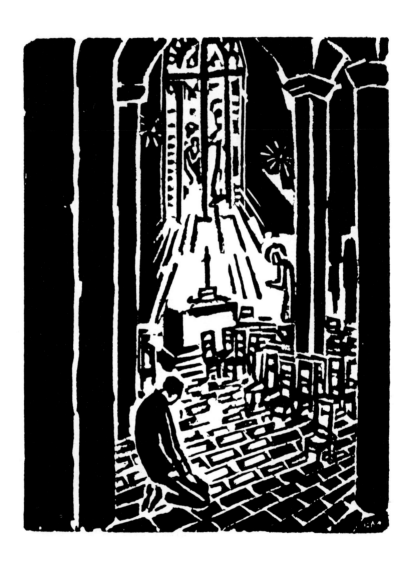

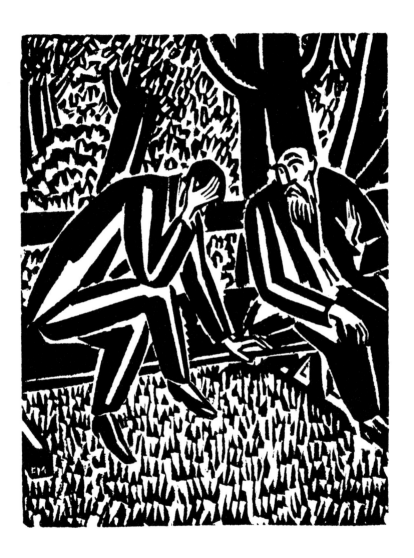

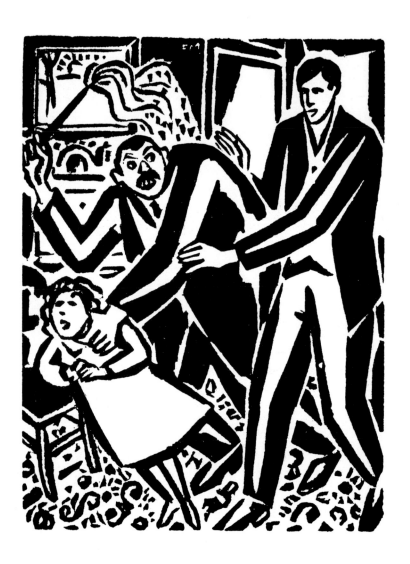

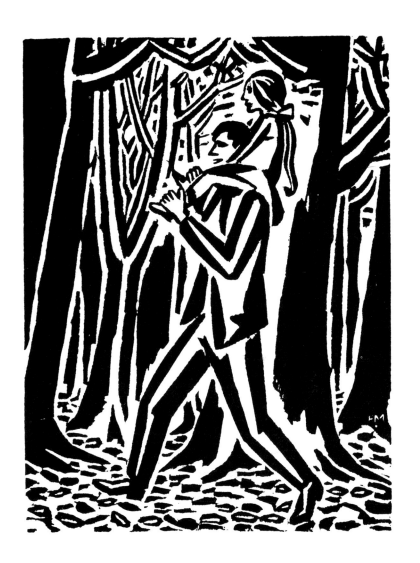

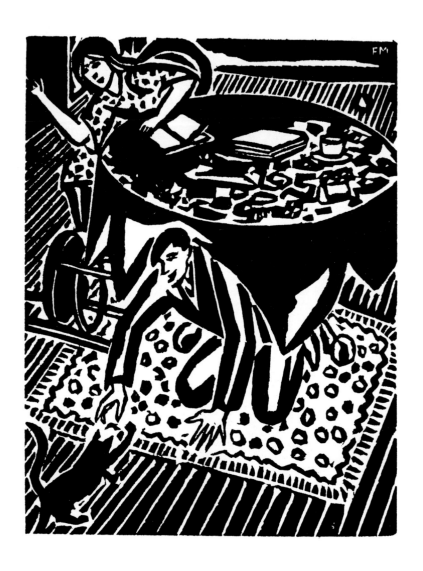

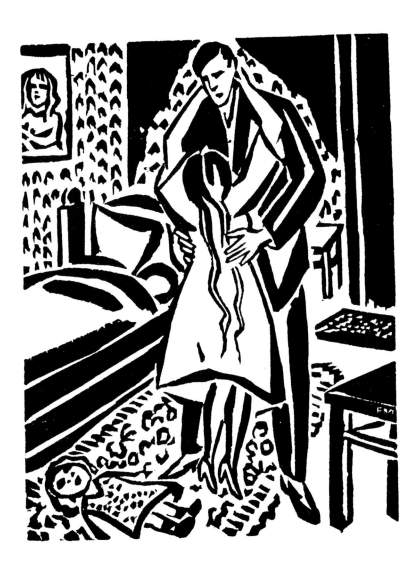

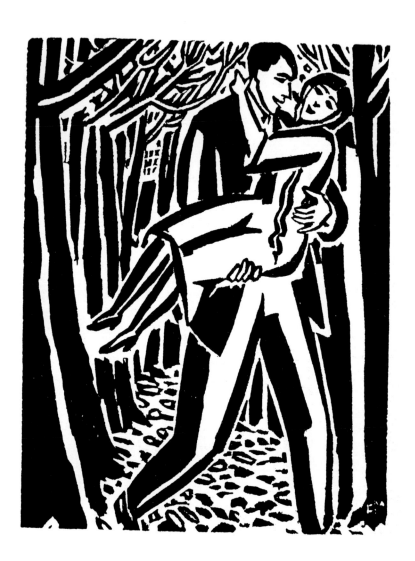

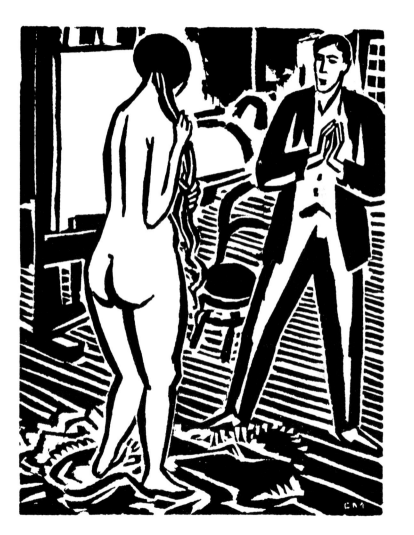

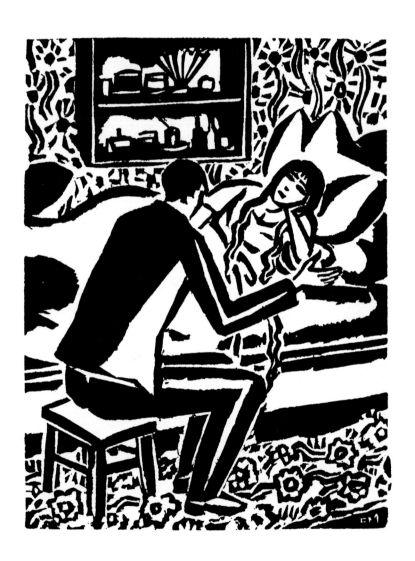

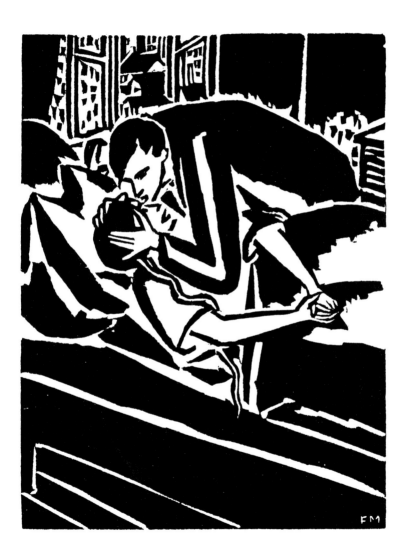

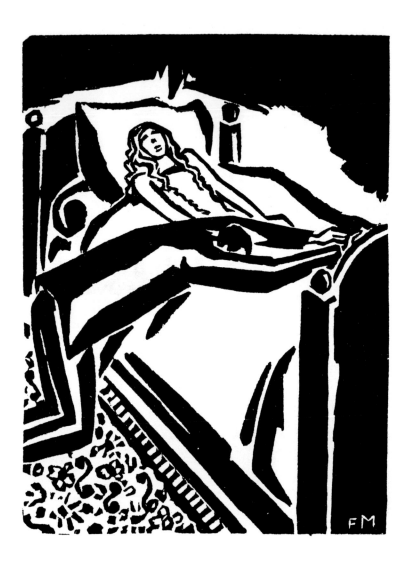

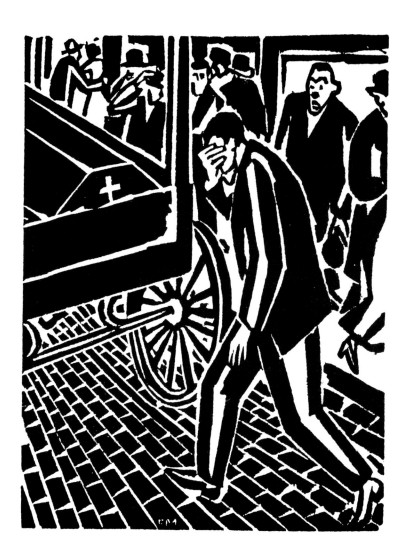

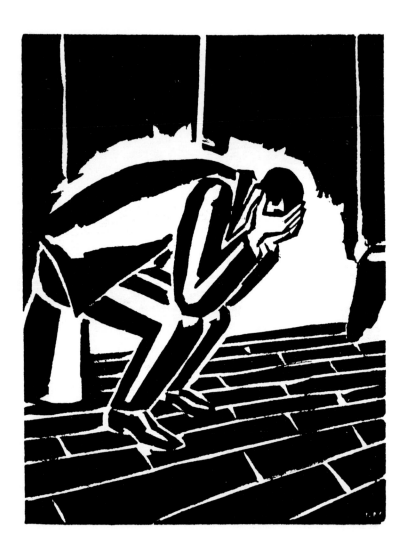

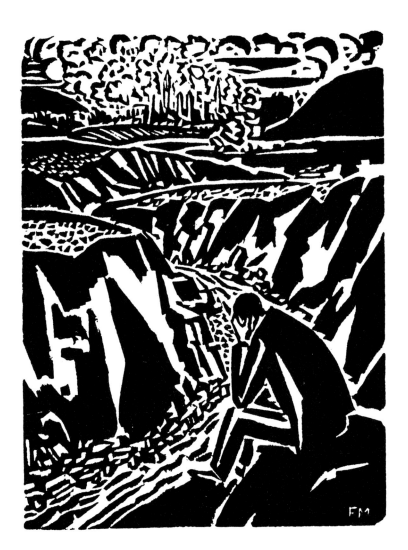

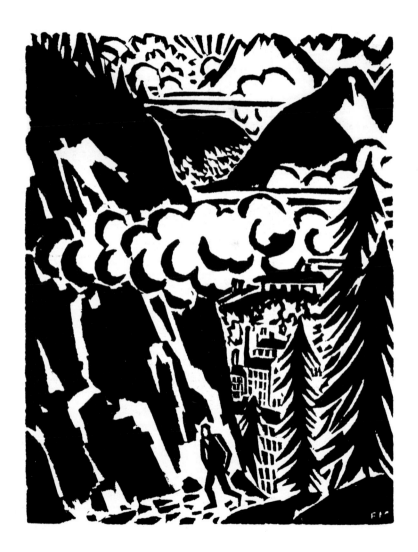

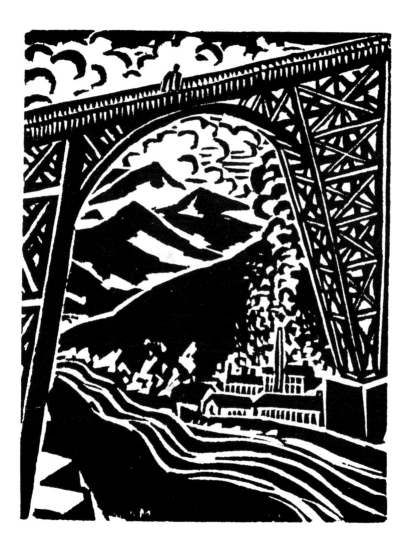

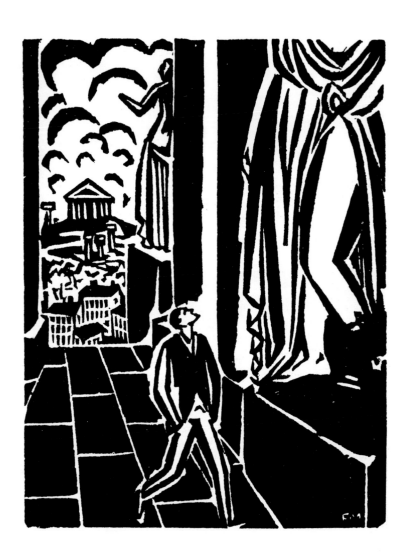

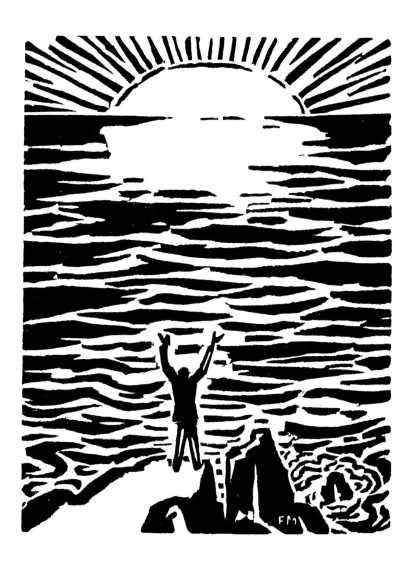

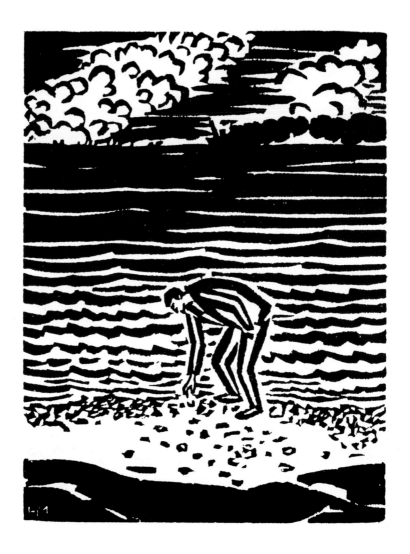

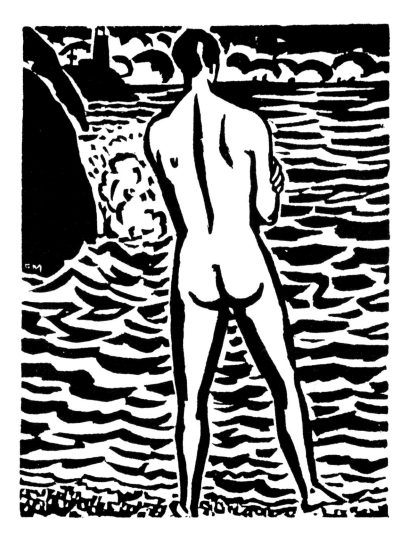

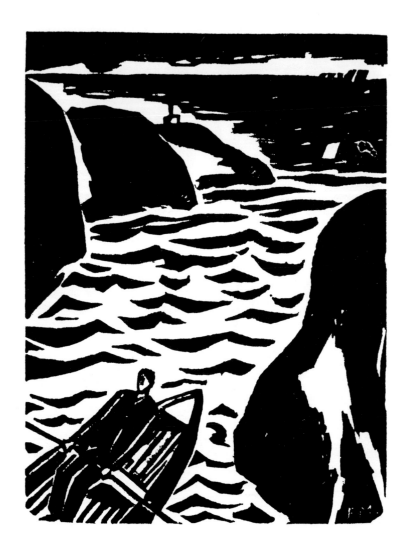

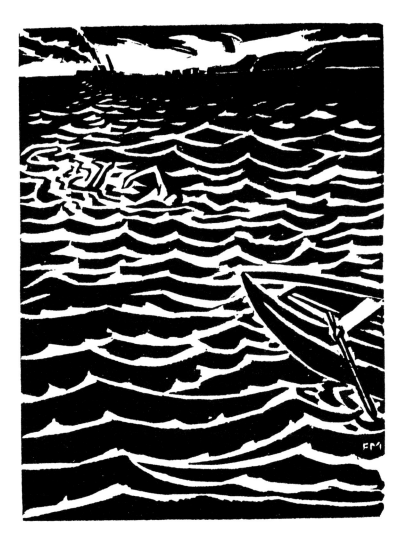

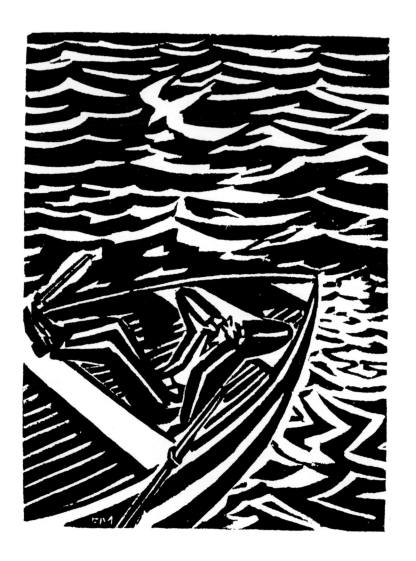

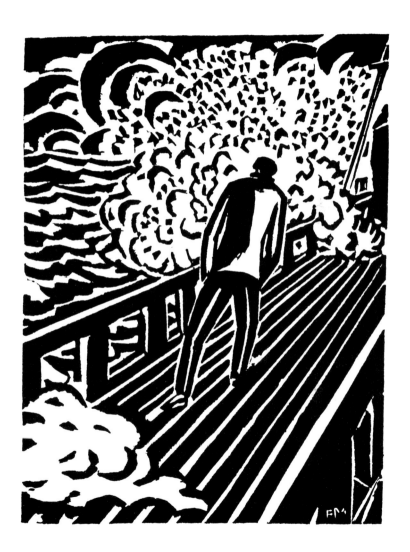

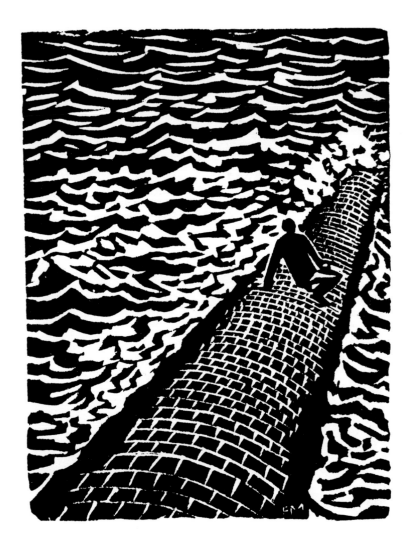

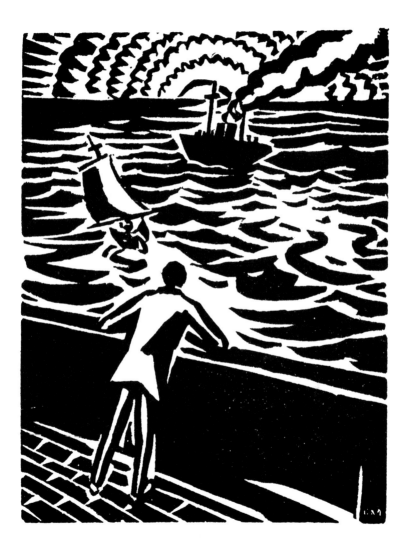

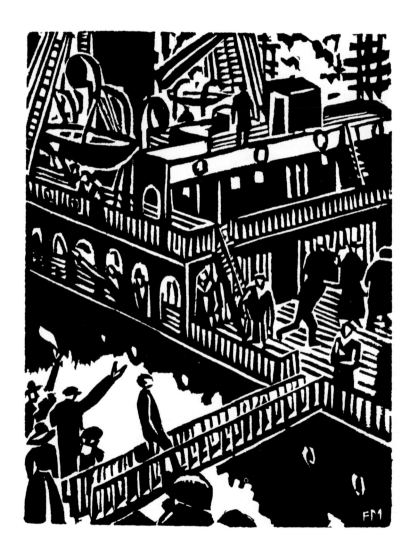

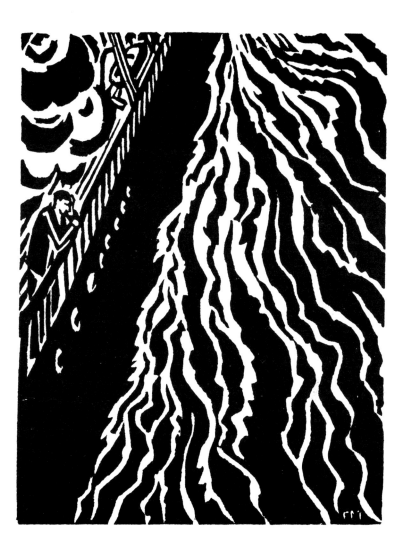

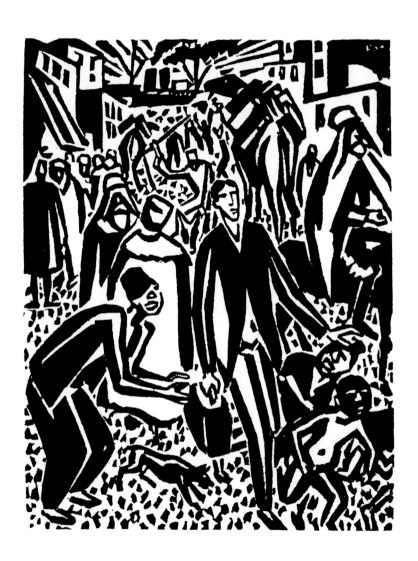

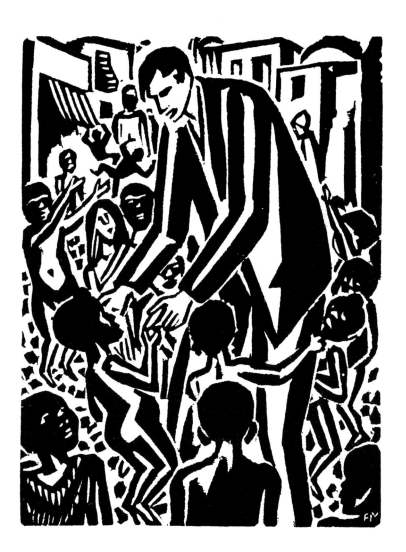

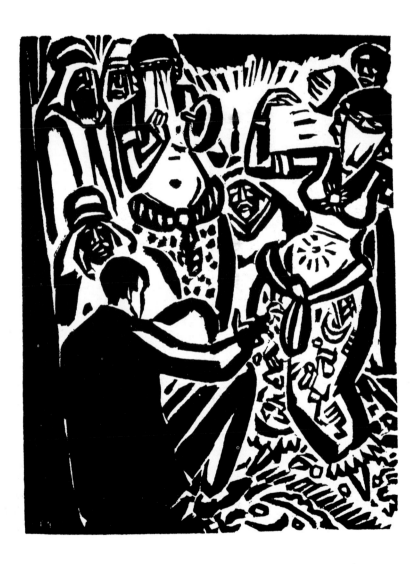

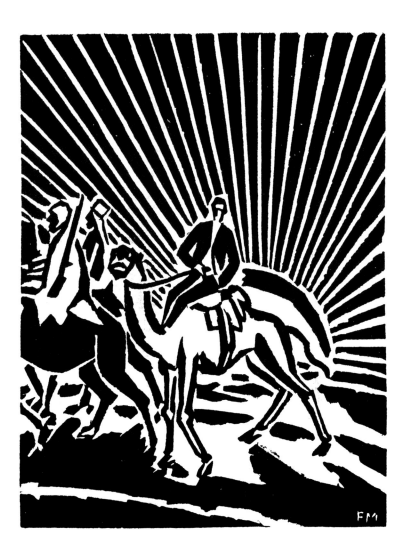

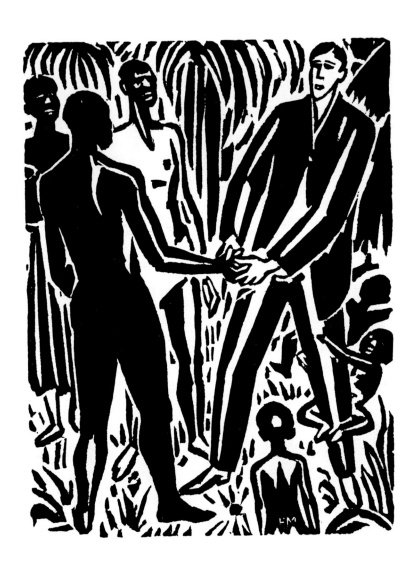

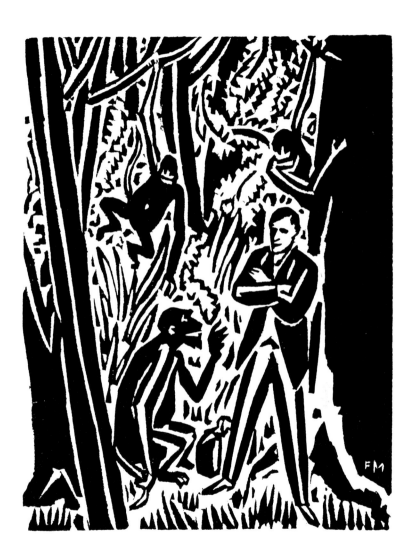

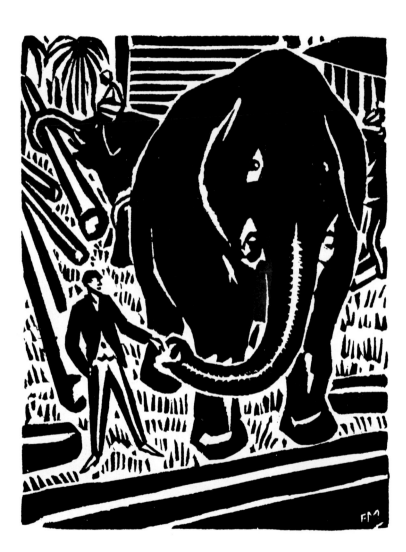

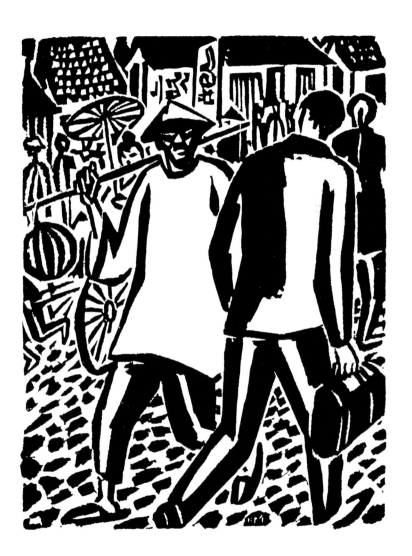

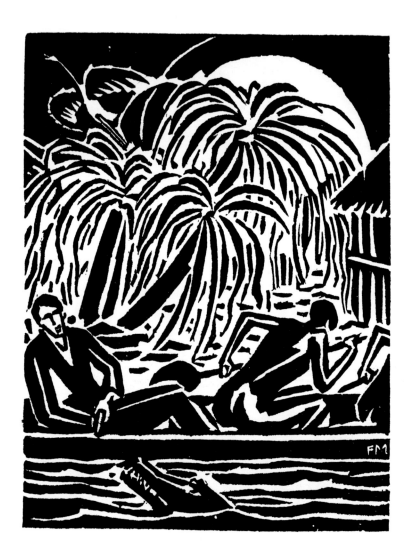

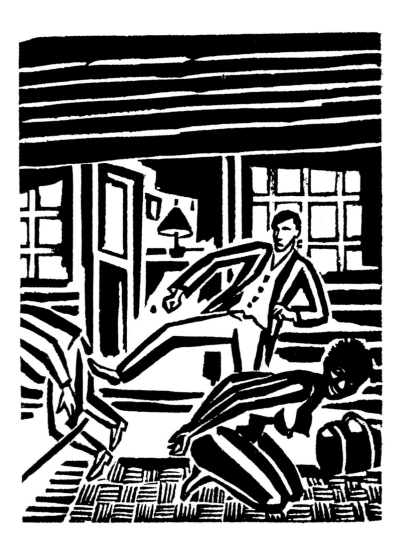

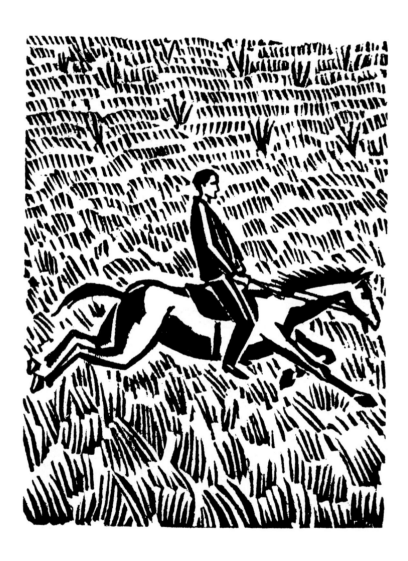

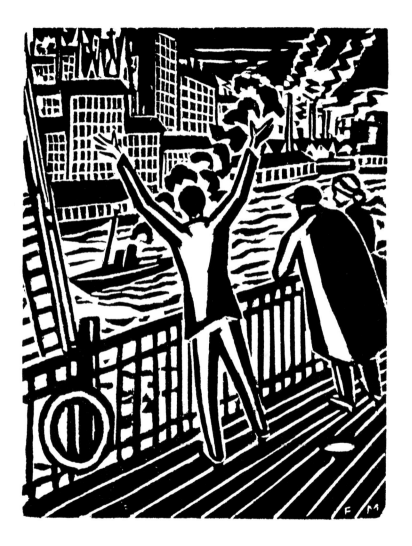

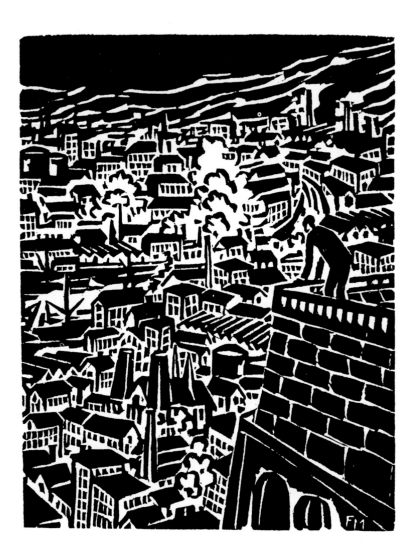

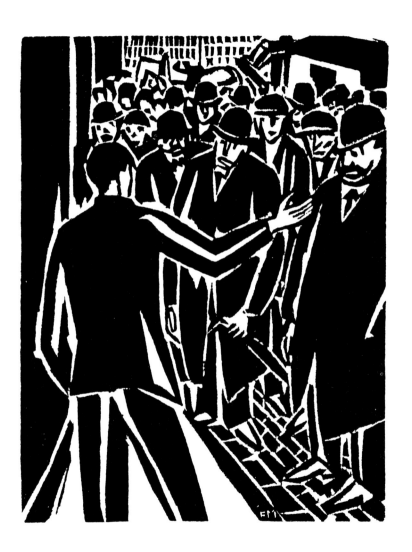

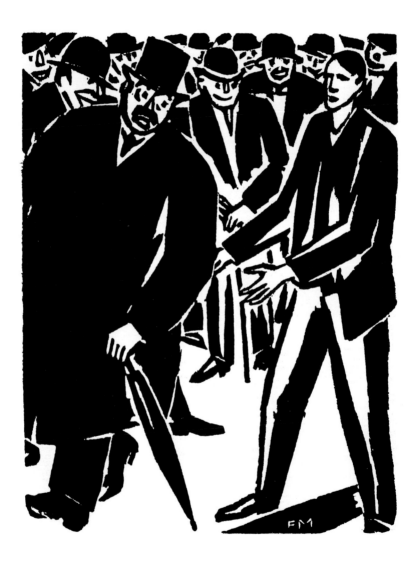

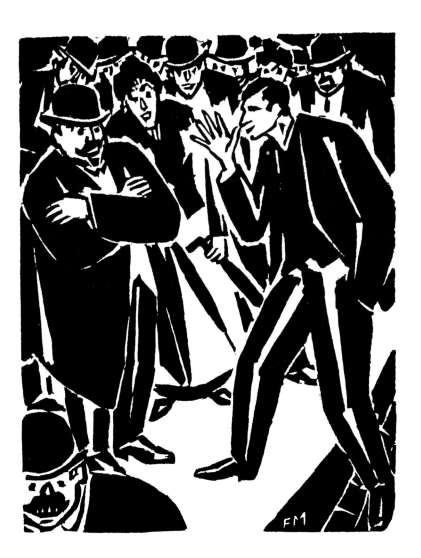

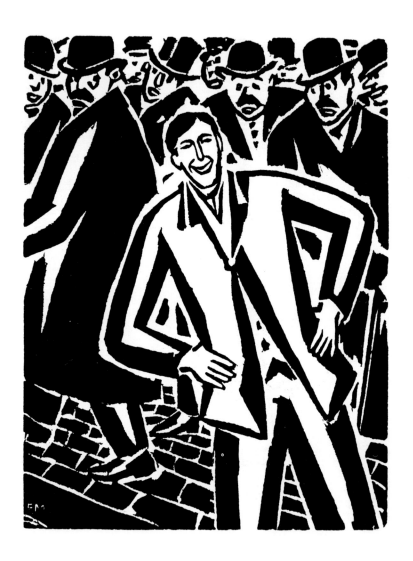

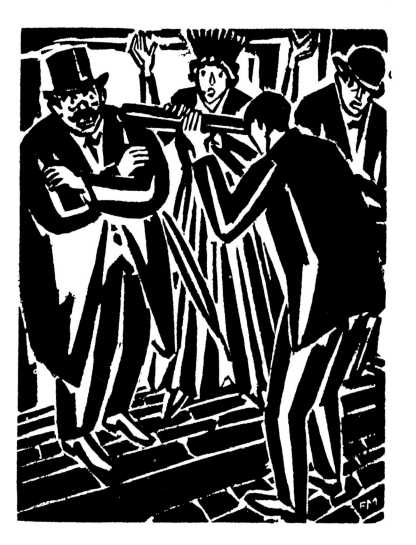

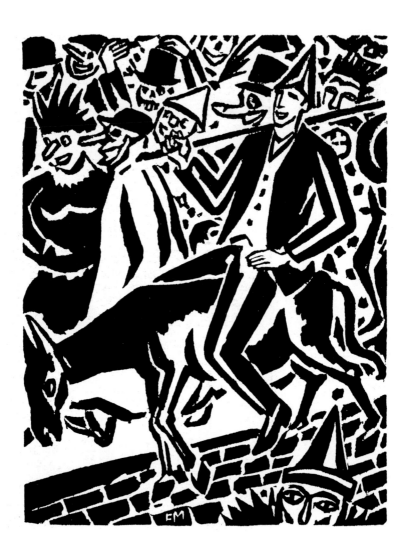

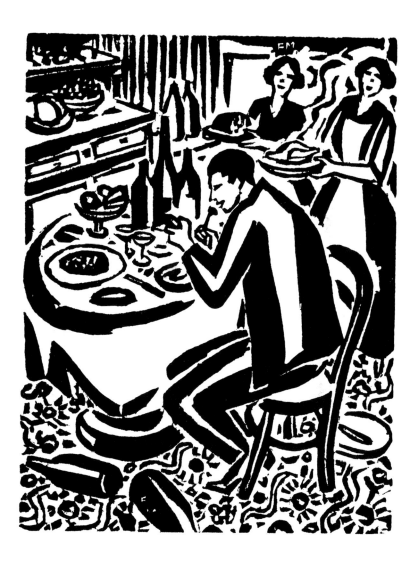

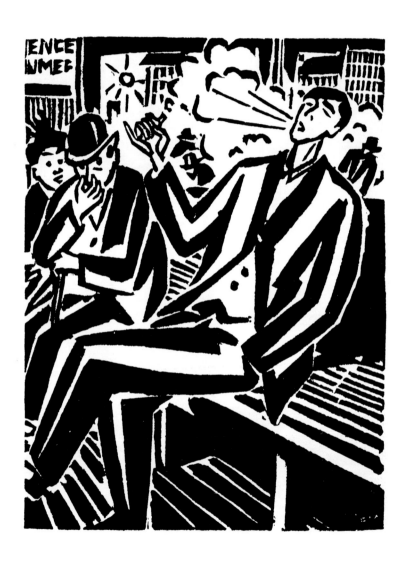

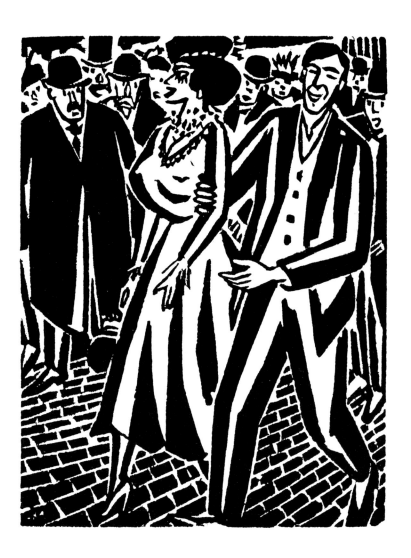

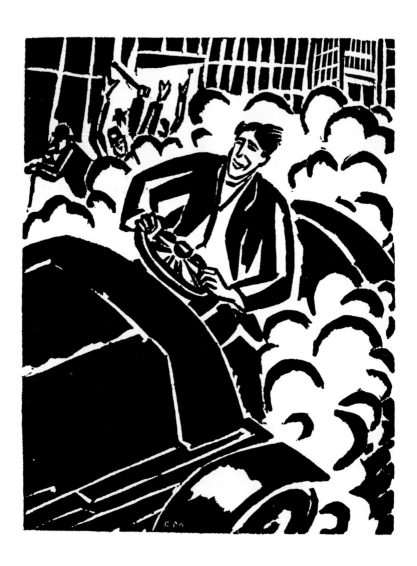

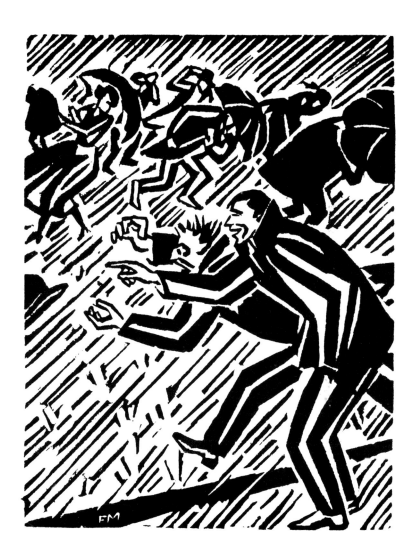

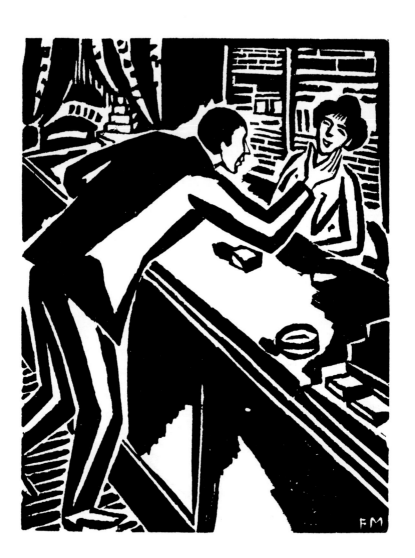

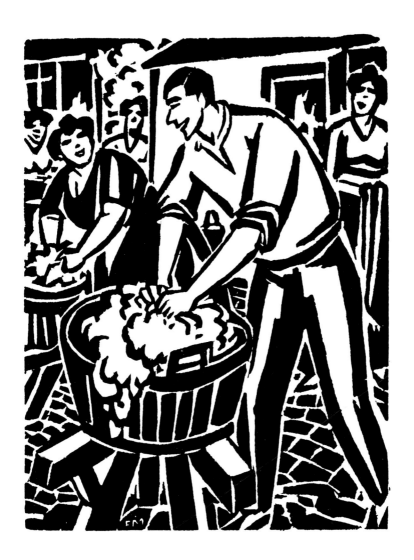

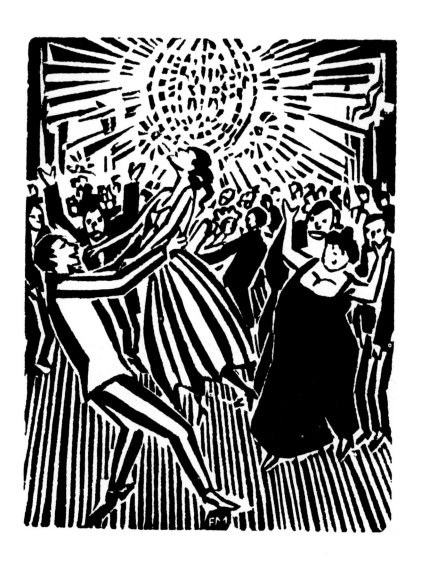

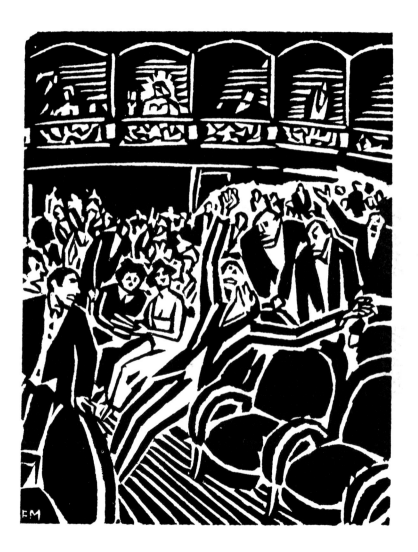

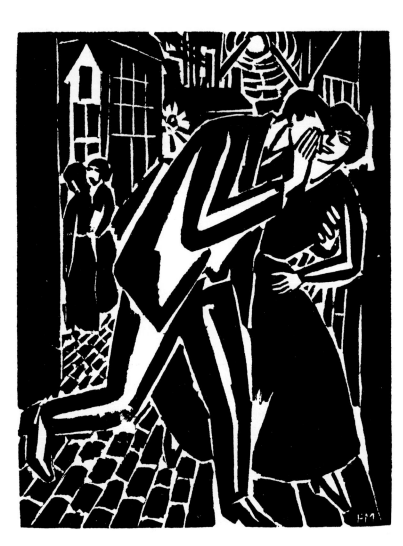

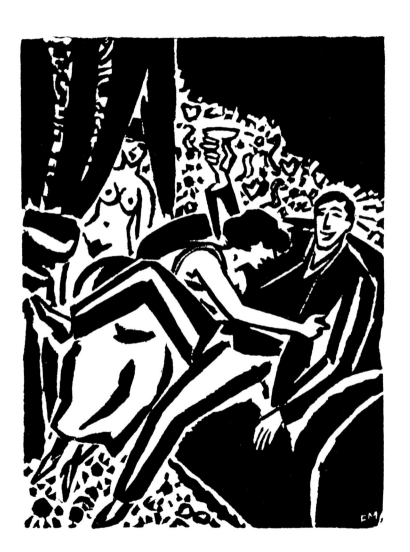

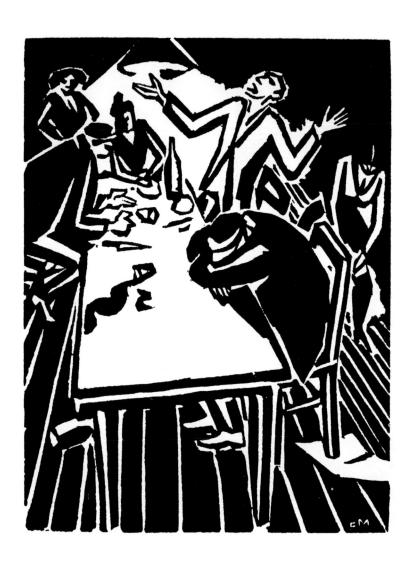

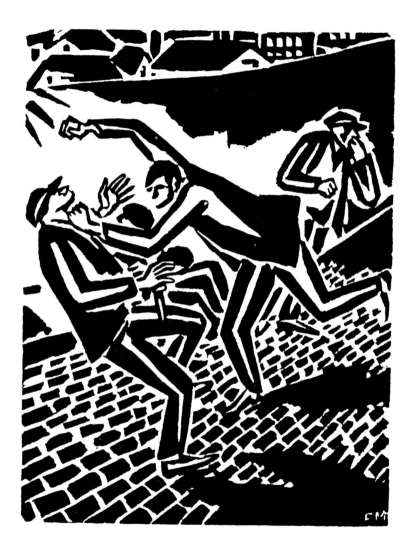

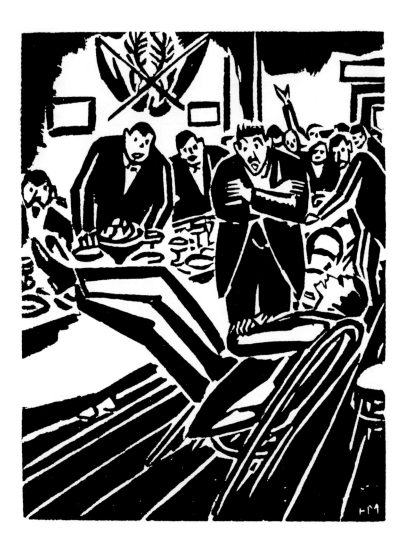

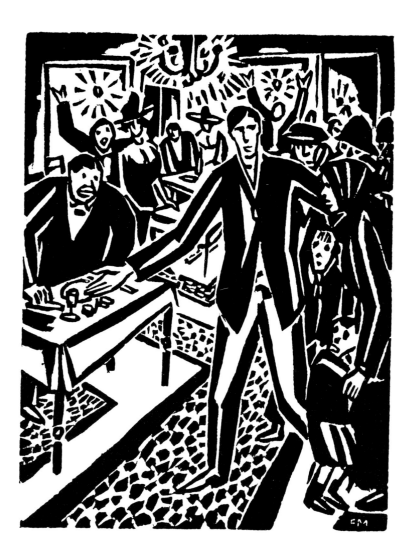

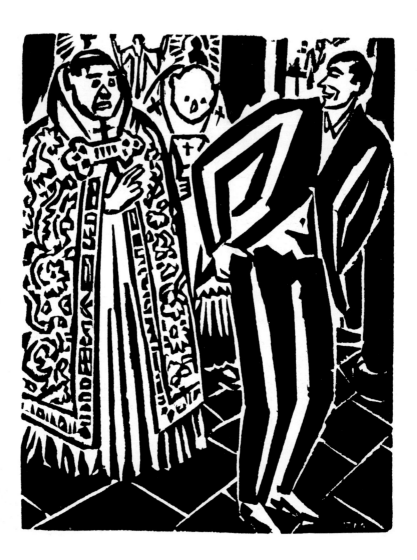

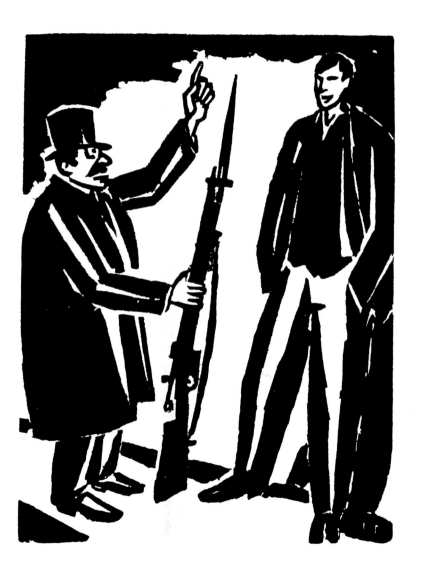

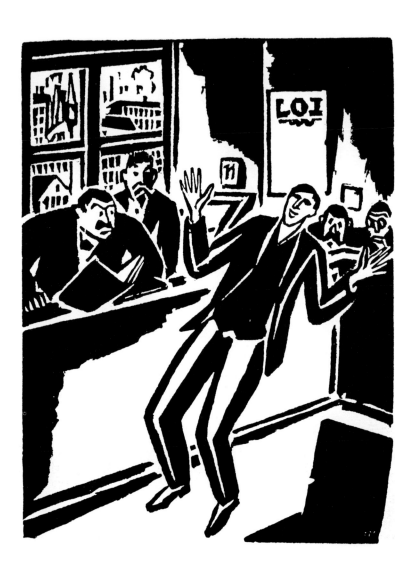

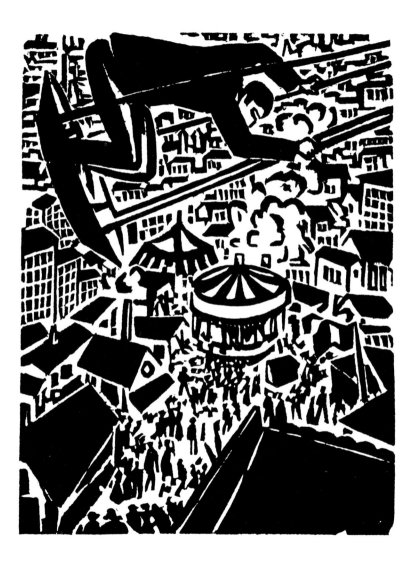

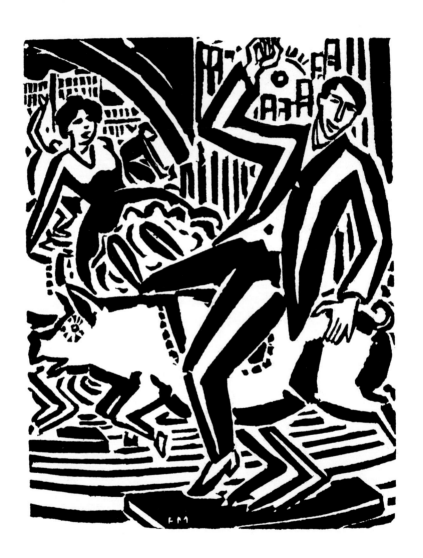

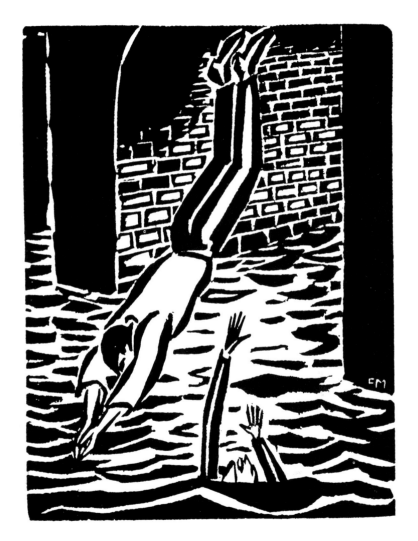

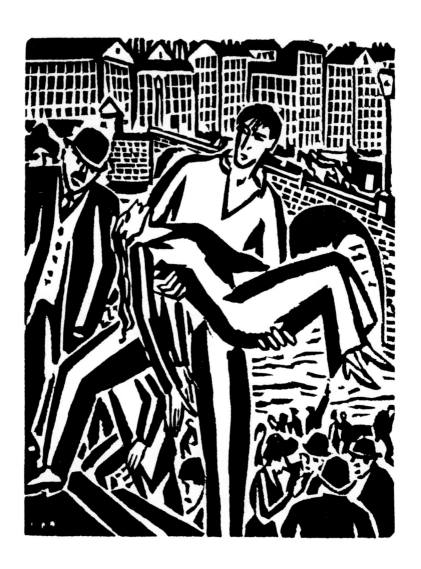

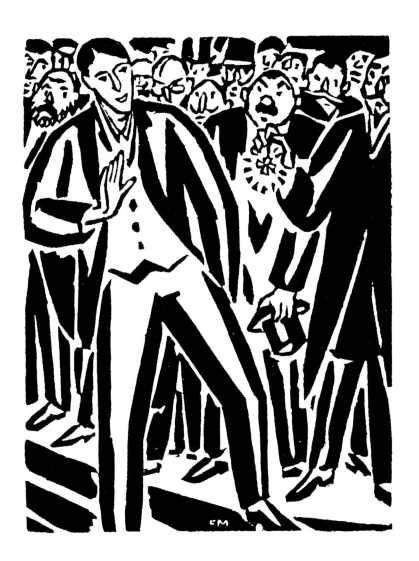

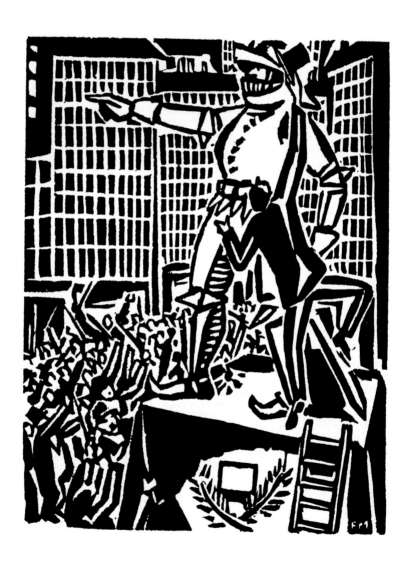

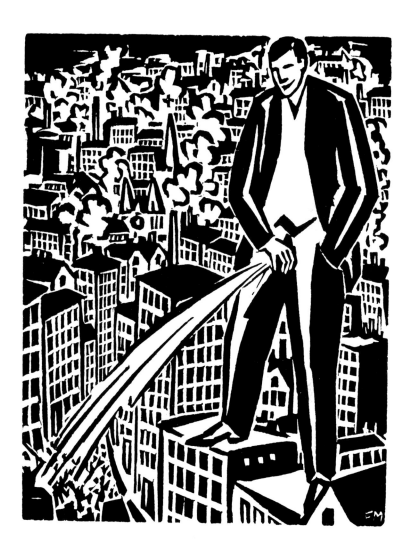

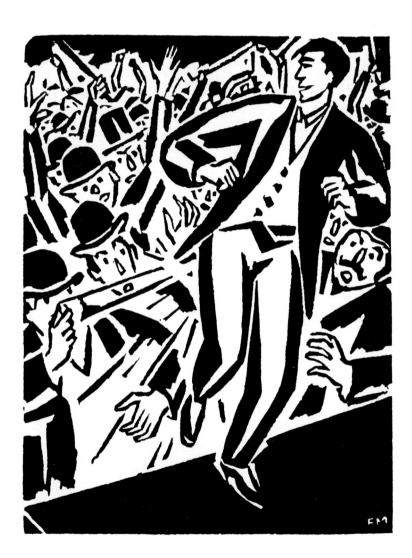

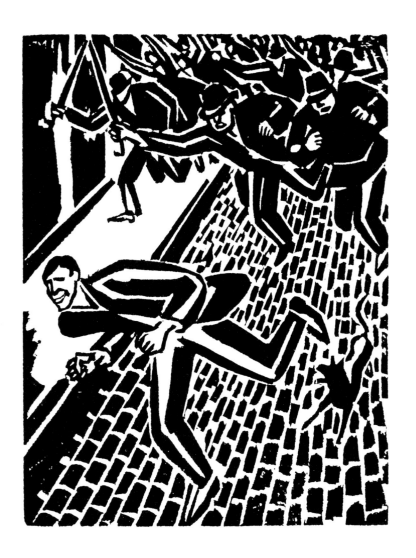

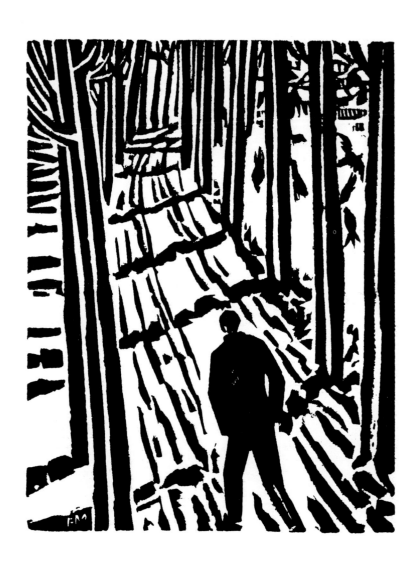

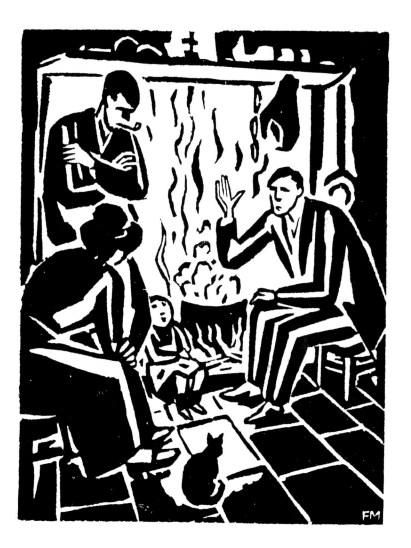

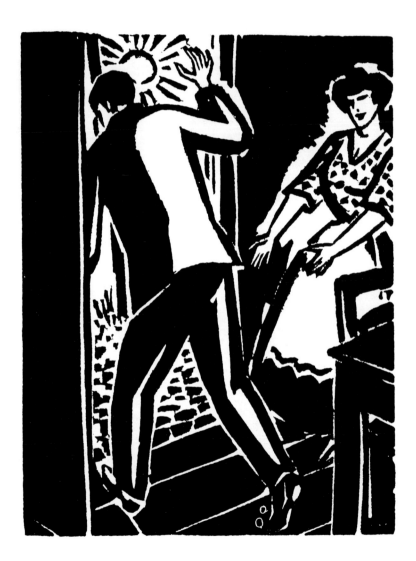

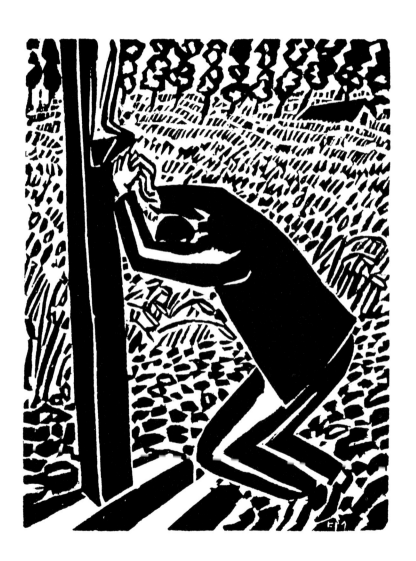

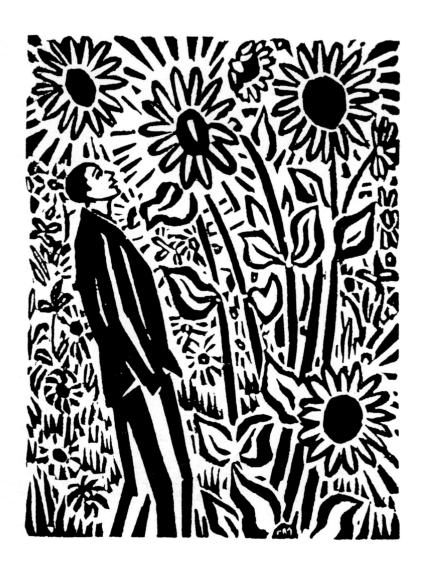

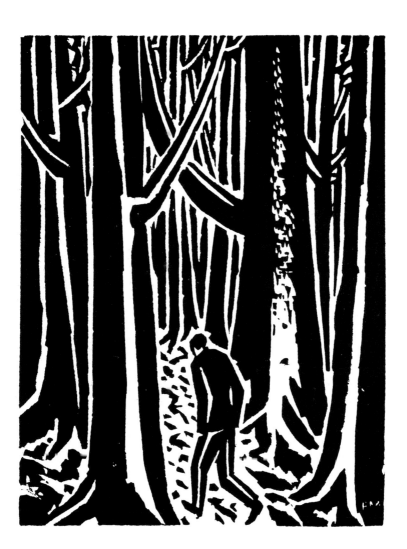

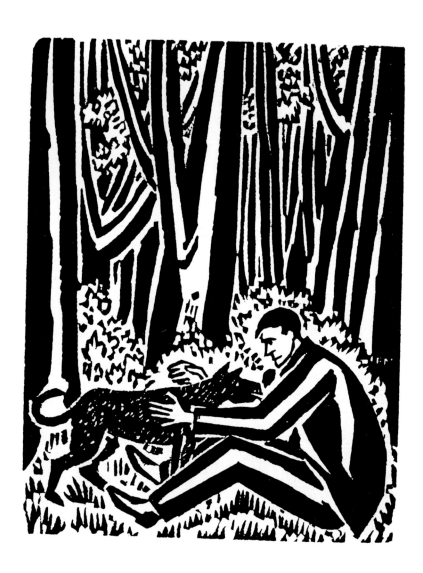

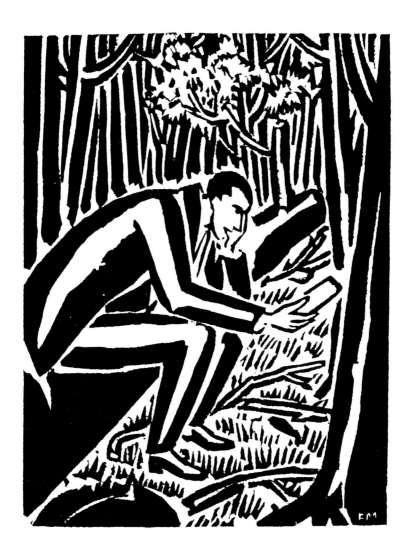

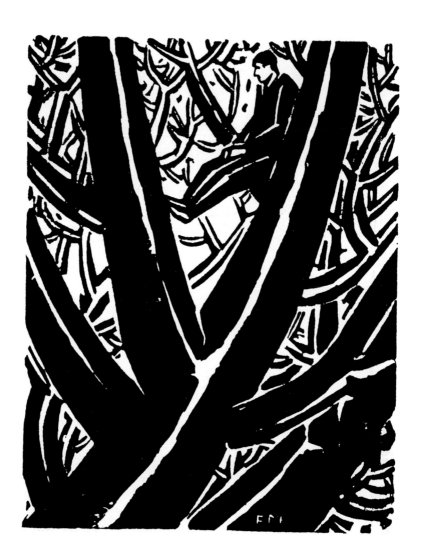

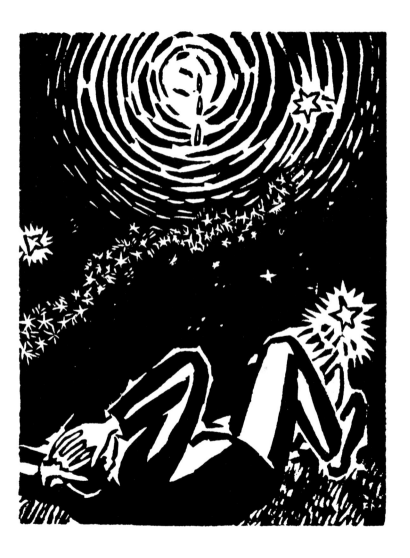

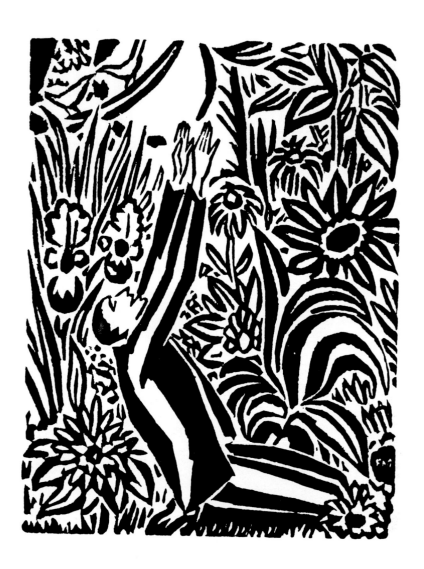

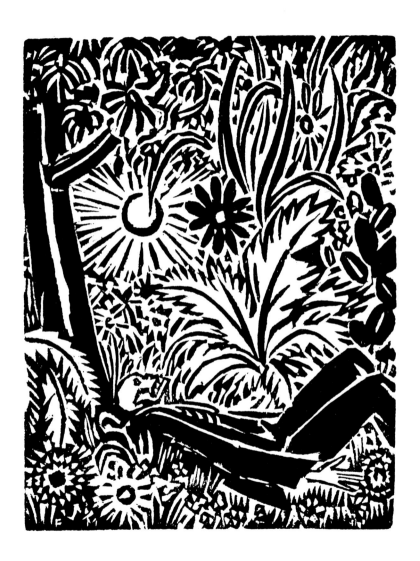

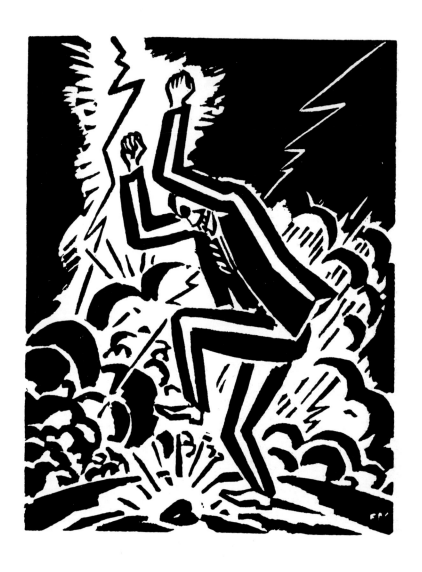

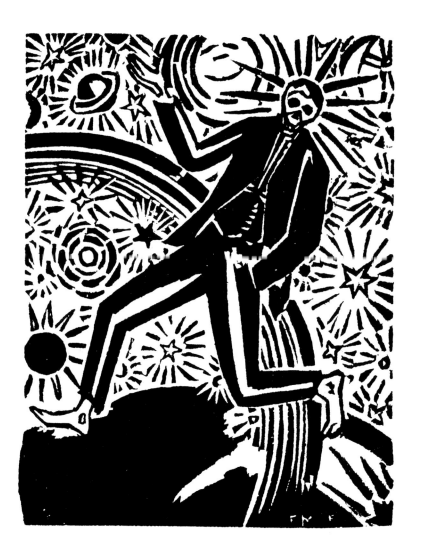

Zy zullen hem niet temmen.

(They shall not tame him.)

—Hendrik Conscience,

'De Leeuw van Vlaanderen'

(The Lion of Flanders)

CITY LIGHTS PUBLICATIONS

Acosta, Juvenal, ed. LIGHT FROM A NEARBY WINDOW: Contemporary Mexican Poetry
Alberti, Rafael. CONCERNING THE ANGELS
Allen, Roberta. AMAZON DREAM
Angulo de, Jaime. INDIANS IN OVERALLS
Angulo de, G. & J. JAIME IN TAOS
Artaud, Antonin. ARTAUD ANTHOLOGY
Bataille, Georges. EROTISM: Death and Sensuality
Bataille, Georges. THE IMPOSSIBLE
Bataille, Georges. STORY OF THE EYE
Bataille, Georges. THE TEARS OF EROS
Baudelaire, Charles. INTIMATE JOURNALS
Baudelaire, Charles. TWENTY PROSE POEMS
Bowles, Paul. A HUNDRED CAMELS IN THE COURTYARD
Bramly, Serge. MACUMBA: The Teachings of Maria-José, Mother of the Gods
Broughton, James. COMING UNBUTTONED
Broughton, James. MAKING LIGHT OF IT
Brown, Rebecca. ANNIE OAKLEY'S GIRL
Brown, Rebecca. THE TERRIBLE GIRLS
Bukowski, Charles. THE MOST BEAUTIFUL WOMAN IN TOWN
Bukowski, Charles. NOTES OF A DIRTY OLD MAN
Bukowski, Charles. TALES OF ORDINARY MADNESS
Burroughs, William S. THE BURROUGHS FILE
Burroughs, William S. THE YAGE LETTERS
Cassady, Neal. THE FIRST THIRD
Choukri, Mohamed. FOR BREAD ALONE
CITY LIGHTS REVIEW #2: AIDS & the Arts
CITY LIGHTS REVIEW #3: Media and Propaganda
CITY LIGHTS REVIEW #4: Literature / Politics / Ecology
Cocteau, Jean. THE WHITE BOOK (LE LIVRE BLANC)
Codrescu, Andrei, ed. EXQUISITE CORPSE READER
Cornford, Adam. ANIMATIONS
Corso, Gregory. GASOLINE
Cuadros, Gil. CITY OF GOD
Daumal, René. THE POWERS OF THE WORD
David-Neel, Alexandra. SECRET ORAL TEACHINGS IN TIBETAN BUDDHIST SECTS
Deleuze, Gilles. SPINOZA: Practical Philosophy
Dick, Leslie. KICKING
Dick, Leslie. WITHOUT FALLING
di Prima, Diane. PIECES OF A SONG: Selected Poems
Doolittle, Hilda (H.D.). NOTES ON THOUGHT & VISION
Ducornet, Rikki. ENTERING FIRE
Duras, Marguerite. DURAS BY DURAS
Eberhardt, Isabelle. DEPARTURES: Selected Writings

Eberhardt, Isabelle. THE OBLIVION SEEKERS
Eidus, Janice. VITO LOVES GERALDINE
Fenollosa, Ernest. CHINESE WRITTEN CHARACTER AS A MEDIUM FOR POETRY
Ferlinghetti, L. ed., ENDS & BEGINNINGS (City Lights Review #6)
Ferlinghetti, Lawrence. PICTURES OF THE GONE WORLD
Ferlinghetti, Lawrence. SEVEN DAYS IN NICARAGUA LIBRE
Finley, Karen. SHOCK TREATMENT
Ford, Charles Henri. OUT OF THE LABYRINTH: Selected Poems
Franzen, Cola, transl. POEMS OF ARAB ANDALUSIA
García Lorca, Federico. BARBAROUS NIGHTS: Legends & Plays
García Lorca, Federico. ODE TO WALT WHITMAN & OTHER POEMS
García Lorca, Federico. POEM OF THE DEEP SONG
Gil de Biedma, Jaime. LONGING: SELECTED POEMS
Ginsberg, Allen. HOWL & OTHER POEMS
Ginsberg, Allen. KADDISH & OTHER POEMS
Ginsberg, Allen. REALITY SANDWICHES
Ginsberg, Allen. PLANET NEWS
Ginsberg, Allen. THE FALL OF AMERICA
Ginsberg, Allen. MIND BREATHS
Ginsberg, Allen. PLUTONIAN ODE
Goethe, J. W. von. TALES FOR TRANSFORMATION
Hayton-Keeva, Sally, ed. VALIANT WOMEN IN WAR AND EXILE
Heider, Ulrike. ANARCHISM: Left Right & Green
Herron, Don. THE DASHIELL HAMMETT TOUR: A Guidebook
Herron, Don. THE LITERARY WORLD OF SAN FRANCISCO
Higman, Perry, tr. LOVE POEMS FROM SPAIN AND SPANISH AMERICA
Jaffe, Harold. EROS: ANTI-EROS
Jenkins, Edith. AGAINST A FIELD SINISTER
Katzenberger, Elaine, ed. FIRST WORLD HA HA HA!
Kerouac, Jack. BOOK OF DREAMS
Kerouac, Jack. POMES ALL SIZES
Kerouac, Jack. SCATTERED POEMS
Kerouac, Jack. SCRIPTURE OF THE GOLDEN ETERNITY
Lacarrière, Jacques. THE GNOSTICS
La Duke, Betty. COMPAÑERAS
La Loca. ADVENTURES ON THE ISLE OF ADOLESCENCE
Lamantia, Philip. MEADOWLARK WEST
Laughlin, James. SELECTED POEMS: 1935-1985
Le Brun, Annie. SADE: On the Brink of the Abyss
Lowry, Malcolm. SELECTED POEMS
Mackey, Nathaniel. SCHOOL OF UDHRA
Marcelin, Philippe-Thoby. THE BEAST OF THE HAITIAN HILLS
Masereel, Frans. PASSIONATE JOURNEY
Mayakovsky, Vladimir. LISTEN! EARLY POEMS
Mrabet, Mohammed. THE BOY WHO SET THE FIRE

Mrabet, Mohammed. THE LEMON
Mrabet, Mohammed. LOVE WITH A FEW HAIRS
Mrabet, Mohammed. M'HASHISH
Murguía, A. & B. Paschke, eds. VOLCAN: Poems from Central America
Murillo, Rosario. ANGEL IN THE DELUGE
Paschke, B. & D. Volpendesta, eds. CLAMOR OF INNOCENCE
Pasolini, Pier Paolo. ROMAN POEMS
Pessoa, Fernando. ALWAYS ASTONISHED
Peters, Nancy J., ed. WAR AFTER WAR (City Lights Review #5)
Poe, Edgar Allan. THE UNKNOWN POE
Porta, Antonio. KISSES FROM ANOTHER DREAM
Prévert, Jacques. PAROLES
Purdy, James. THE CANDLES OF YOUR EYES
Purdy, James. IN A SHALLOW GRAVE
Purdy, James. GARMENTS THE LIVING WEAR
Purdy, James. OUT WITH THE STARS
Rachlin, Nahid. MARRIED TO A STRANGER
Rachlin, Nahid. VEILS: SHORT STORIES
Reed, Jeremy. DELIRIUM: An Interpretation of Arthur Rimbaud
Reed, Jeremy. RED-HAIRED ANDROID
Rey Rosa, Rodrigo. THE BEGGAR'S KNIFE
Rey Rosa, Rodrigo. DUST ON HER TONGUE
Rigaud, Milo. SECRETS OF VOODOO
Ruy Sánchez, Alberto. MOGADOR
Saadawi, Nawal El. MEMOIRS OF A WOMAN DOCTOR
Sawyer-Lauçanno, Christopher, tr. THE DESTRUCTION OF THE JAGUAR
Scholder, Amy, ed. CRITICAL CONDITION: Women on the Edge of Violence
Sclauzero, Mariarosa. MARLENE
Serge, Victor. RESISTANCE
Shepard, Sam. MOTEL CHRONICLES
Shepard, Sam. FOOL FOR LOVE & THE SAD LAMENT OF PECOS BILL
Smith, Michael. IT A COME
Snyder, Gary. THE OLD WAYS
Solnit, Rebecca. SECRET EXHIBITION: Six California Artists
Sussler, Betsy, ed. BOMB: INTERVIEWS
Takahashi, Mutsuo. SLEEPING SINNING FALLING
Turyn, Anne, ed. TOP TOP STORIES
Tutuola, Amos. FEATHER WOMAN OF THE JUNGLE
Tutuola, Amos. SIMBI & THE SATYR OF THE DARK JUNGLE
Valaoritis, Nanos. MY AFTERLIFE GUARANTEED
Wilson, Colin. POETRY AND MYSTICISM
Wilson, Peter Lamborn. SACRED DRIFT
Wynne, John. THE OTHER WORLD
Zamora, Daisy. RIVERBED OF MEMORY

N

W **CITY LIGHTS PUBLISHERS AND BOOKSELLERS** E

S

CITY LIGHTS MAIL ORDER
Order books from our free catalog:

all books from CITY LIGHTS PUBLISHERS and more

write to:

CITY LIGHTS MAIL ORDER

261 COLUMBUS AVENUE SAN FRANCISCO, CA 94133

or fax your request to [415] 362-4921